COLOR IN THE 21ST CENTURY

COLOR IN THE 21ST CENTURY

A PRACTICAL GUIDE FOR GRAPHIC DESIGNERS, PHOTOGRAPHERS, PRINTERS, SEPARATORS, AND ANYONE INVOLVED IN COLOR PRINTING

HELENE W. ECKSTEIN

WATSON-GUPTILL PUBLICATIONS/NEW YORK

Copyright © 1991 by Helene Eckstein

First published in 1991 by Watson-Guptill Publications,
a division of BPI Communications, Inc.,
1515 Broadway, New York, NY 10036

Library of Congress Cataloging-in-Publication Data

Eckstein, Helene W.
 Color in the 21st century : a practical guide for graphic
designers, photographers, printers, separators, and anyone involved
in color printing / Helene W. Eckstein.
 p. cm.
 Includes index.
 ISBN 0-8230-0743-X :
 1. Color-printing. 2. Color photography—Printing processes.
I. Title. II. Title: Color in the twenty-first century.
Z258.E25 1991
686.2'3042—dc20 91-14094
 CIP

Manufactured in Singapore

First printing, 1991

1 2 3 4 5 6 7 8 9/96 94 93 92 91

ACKNOWLEDGMENTS

An undertaking like writing a book is a time of personal reflection. You recall who influenced you, taught you, nurtured your efforts, and therefore made the book a reality.

First, to my parents, Benjamin and Sylvia Wohl, I thank you for giving me the confidence to try anything and for the unconventional wisdom that makes me achieve.

To my former husband, Erwin, I owe most of my knowledge. He brought me into this business and supported me every step of the way. He is the most knowledgeable person I've met in this industry.

To my friends, Marsha Simchera, Bill Humphries, and Steve Christensen, I owe hours of telephone calls and lots of encouragement. To Amy Flynn, my secretary, there would be no book and no seminars and no writing if not for your patiently transcribing innumerable tapes and diskettes and staying odd hours to accommodate a schedule that, at best, could be described as chaotic.

To some of my business associates, Paul Levine, Paul Uselmann, Joe Weissman, Victoria Cohen, Cyndi Schulman, Rob Schweiger, Suzanne Rogers, and the Bobit Publishing Crew, thank you for teaching me this business and always being my friends. And to my other friends who still know nothing of this industry but know and love me, I thank you for being there, for sharing dinners in every city, and for always telling me I could accomplish anything.

Thanks to my editors, Mary Suffudy and Paul Lukas, for hours of patience and incredible guidance. Writing a book can be an intimidating experience, but you made it seem easy.

To the graphic arts suppliers, I say thank you and thank you again. You gave unselfishly of your time and materials to make all this happen.

And a final thank you to Spectrum, its clients, and employees. It's you who provided the real-world experience I write about. This book is, in essence, your story.

CONTENTS

PREFACE

When undertaking the task of writing a book on a subject with which you have been involved for many years, there is a natural tendency to think back and remember how you first learned the subject and what influenced that learning. Prior to 1976, I knew nothing about the world of color printing, and looked at picture books like many of my non–graphic arts friends do—everything looked good to me. After all, the very fact that images are in color makes them attractive. Most people give little or no thought to the intricacies and subtleties of tone and nuance that occupy our many sleepless nights in the color industry.

In 1976, however, my partner and I started Spectrum, and I was soon to be transformed from a guidance counselor and journalist to a color separator. My life changed dramatically and color printing began to dominate my life.

I remember looking at the graphic arts world back then and being amazed by the almost mystical ways that information was transmitted in the color-communication business. Most people seemed to learn the tricks of trade from their suppliers, who taught by trial and error—that is, they made errors that cost their companies money, caused them embarrassment, or resulted in a bad job. When they questioned their suppliers, they were told, "If only you had . . .," slapped on the wrist, and told how to do it the next time.

This process would continue for years—the trial and error, the "if only"s and reprimands, until, after 20 years or more, most people accumulated enough data

to do their jobs well. But it seemed so unnecessary to wait 20 years and spend so much time and effort. That's why I started teaching color printing seminars that could be understood by creative people and put into practice immediately.

In this book, I am recreating and updating the courses that I have conducted for the past 15 years. It is my hope that my many seminar attendees and old pros will benefit from reviewing their experiences and also add to their pool of knowledge. To the newcomers, just beginning their careers, I hope you will avoid 20 years of mistakes and proceed immediately to the good feeling that comes from knowing you have the knowledge and expertise to do your job well.

This book is intended to be a practical working textbook. Throughout the text are handy checklists, which can be photocopied for easy reference. When you need further explanation of a topic, refer to the expanded text in the book. The book also includes order forms, bid request forms, inventory sheets, and other forms for you to use. Make photocopies of all these documents and keep them for future use—you will get your best value from this book by using the materials enclosed.

The outlook for color reproduction is exciting—new technologies are rapidly rewriting the rules and standards of the industry, and many businesses that would never have considered color print jobs in years past are now entering the color marketplace. There is a lot to know and a lot to anticipate—my hope is that this book will aid you in your efforts.

1 HOW WE SEE COLOR

Color, in and of itself, does not exist. An object's color is determined solely by which wavelengths of light are absorbed by the object and which ones filter back to our eyes. For instance, if we're in a forest on a sunny day, the leaves on the trees appear green. But when we return to the same spot in the evening, the leaves now look gray. The leaves themselves are obviously unchanged, but the lighting is different, and thus our color perception is altered.

SIR ISAAC NEWTON AND THE PRISM

This phenomenon, along with many of its wider implications, were first noted in 1666, by 23-year-old Isaac Newton. Newton discovered that by passing a beam of light through a prism, he was able to see the visible spectrum of light. Furthermore, when he later passed the same light beam through a second prism, the white light spectrum then became whole once again.

An apple appears red because it absorbs two wavelengths of light, the blue and the green, leaving the third wavelength, red, to filter back to our eyes. (Courtesy of Du Pont Printing and Publishing)

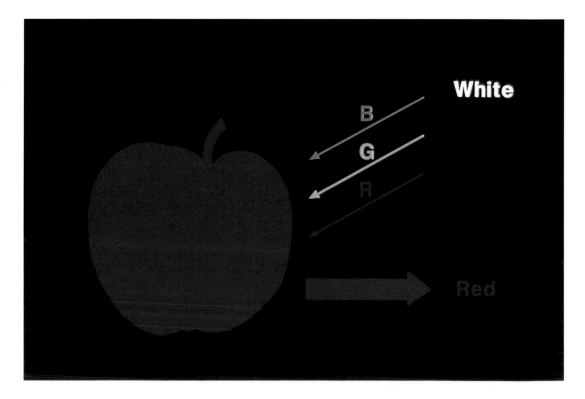

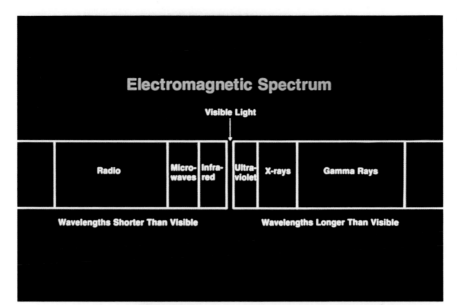

Electromagnetic Spectrum

Visible Light

| Radio | Micro-waves | Infra-red | Ultra-violet | X-rays | Gamma Rays | |

Wavelengths Shorter Than Visible **Wavelengths Longer Than Visible**

The visible spectrum is only a small part of the entire spectrum of light. (Courtesy of Du Pont Printing and Publishing)

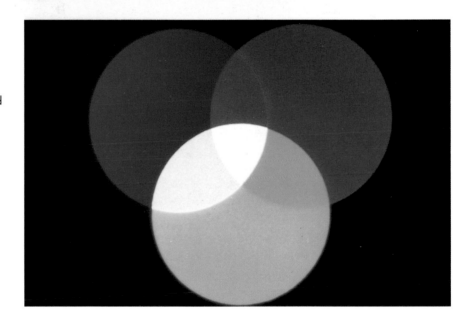

All white light is composed of three bands of light: red, green, and blue. These are the additive colors used in video, but they are not the printing colors. (Courtesy of Du Pont Printing and Publishing)

All color is light. The *visible* spectrum of light, however, is only a small portion of the entire wavelength spectrum, which includes the ultraviolet portion that cannot be detected by the naked eye. The visible spectrum consists of three wavelengths of light: red, green, and blue. The red is the longest wavelength, followed by the green, and then the blue. The various combinations of these three light wavelengths are interpreted by the human brain as a particular color.

Any color that we see represents those portions of the three bands of light that are *not* absorbed by the observed object and instead filter back to our eyes. An apple, therefore, appears red because all light bands except red are absorbed by the object, while the red is reflected back to us.

These three colors of light—red, green, and blue—are known as the *primary colors* (or the additive colors, or simply the primaries). They are the colors that are used in video, and appear on a desktop computer screen. When combined, they produce white light; when mixed in varying intensities, they can form every other color that our eyes are capable of seeing.

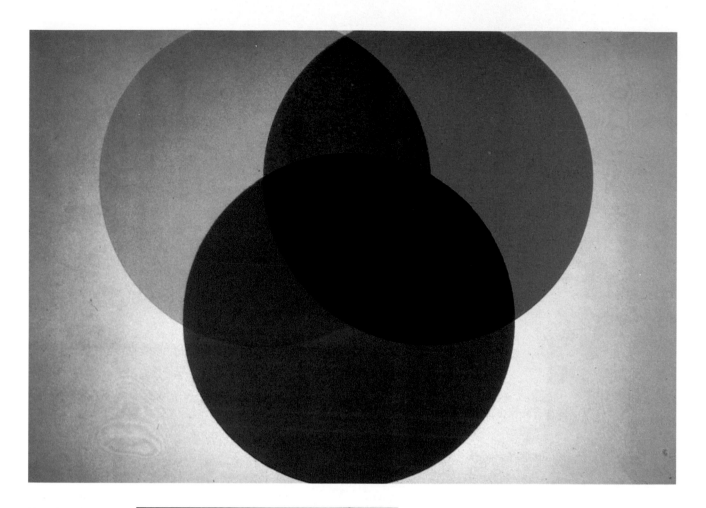

The subtractive printing colors are yellow, magenta, and cyan. In theory, when combined, they should produce black, but with printing ink pigments, the combination yields a muddy brown color. (Courtesy of 3M Printing and Publishing Systems Division)

SUBTRACTIVE COLOR THEORY

We do not print with the primary colors. Rather, we print with the *subtractive colors* (or secondary colors). These are the colors that are created when two wavelengths of light combine in the absence of the third. The subtractive colors are yellow, magenta, and cyan. When combined, they produce black, just as the combination of the primaries produces white.

Subtractive color theory is the basis of four-color printing. Printers create *color separations*, using a series of filters to subtract light from one of the primaries and thus form one of the subtractive printing colors. Another way to look at the process is that all separation negatives are based on "minus" colors. Cyan is minus-red, magenta is minus-green, and yellow is minus-blue. For example, a red filter is used to subtract red light from white light, leaving the blue and green, which combine to create the cyan negative. Similarly, a green filter will subtract the green component of light, leaving the blue and red

bands, which create the magenta negative. And the blue filter will subtract the blue band of light, leaving the red and green and thus creating the yellow negative.

The printing paper (or *substrate*) itself already contains all color. No color is physically added to the paper—instead, components of light (and thus color) are subtracted from the printing substrate. The printing inks act as filters and absorb some portions of color and reflect others back to our eyes.

DEFICIENCIES OF PRINTING INKS

In the printing process, each color image is broken down, or *separated*, into the proper level of each of the subtractive colors plus black (hence the term *four-color printing*). On the printing press, these four colors are applied in the form of inks.

Although color printing uses subtractive color theory as its theoretical basis, the realities of printing inks present some unique problems. Printing inks are

The blue wavelength of light combined with the green wavelength in the absence of red produces cyan. (Courtesy of Du Pont Printing and Publishing)

The red wavelength of light combined with the blue wavelength in the absence of green produces magenta. (Courtesy of Du Pont Printing and Publishing)

The red wavelength of light combined with the green wavelength produces yellow. (Courtesy of Du Pont Printing and Publishing)

pigments rather than dyes, which means they contain impurities that react differently than the purer dyes (such as those used in photographic slides or prints), which strictly adhere to the rules of subtractive color theory.

The ideal cyan ink, for example, should reflect equal parts of green and blue light; the ideal magenta ink should reflect equal amounts of red and blue light; and the ideal yellow ink should reflect equal amounts of red and green. The typical cyan ink, however, is bluer, grayer, and less green, and has an unwanted red component. The typical magenta ink has less blue than desired and has an unwanted green component, making it redder and duller than the ideal. The typical yellow ink is likewise too red and duller than the ideal because it is insufficiently green and has an unwanted blue component.

And there are other problems: For instance, magenta plus cyan should produce blue, while yellow plus cyan should yield green, and magenta plus yellow should produce red. With typical printing inks, however, the combination of magenta plus cyan creates a dull blue or violet, rather than a true blue, forcing the separator to compensate by reducing the amount of magenta in all blue-light areas. Similarly, the combination of cyan and yellow gives a green that is dull and yellowish, and the color separator must compensate by reducing the yellow. Finally, the red created by a combination of magenta and yellow is orange-ish, and therefore the separator must reduce the amount of yellow.

Thus all printing inks are deficient and unbalanced, complicating the task for the color separator, who must interpret these deficiencies and produce negatives that will print color as desired. This process, known as *color correction*, is one of the main challenges for the color separator and one of the prime factors in determining the quality of the reproductions.

HOW OUR EYES SEE COLOR

Most of us believe we see color well. It is only by accurate testing, however, that we can diagnose our own deficiencies and make accurate color judgments.

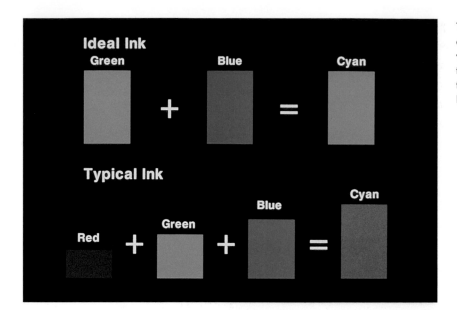

The ideal cyan ink should have equal amounts of green and blue with no red component, but the typical cyan ink differs from this ideal. (Courtesy of Du Pont Printing and Publishing)

The ideal yellow ink should have equal parts of red and green with no blue component, but the typical yellow ink differs from this ideal. (Courtesy of Du Pont Printing and Publishing)

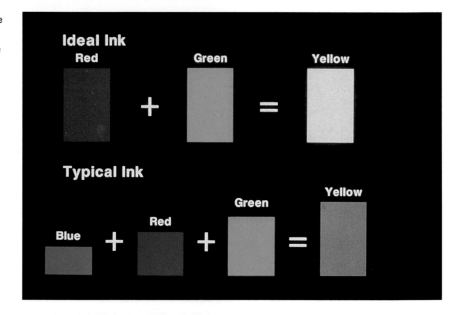

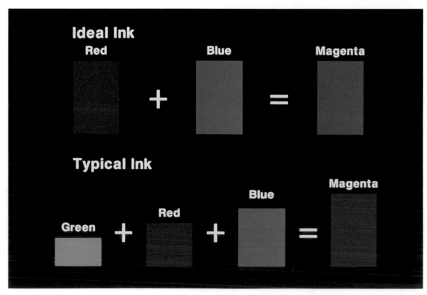

The ideal magenta ink should have equal parts of red and blue with no green component, but the typical magenta ink differs from this ideal. (Courtesy of Du Pont Printing and Publishing)

We see color through our eyes. The retina of the human eye has photosensitive cells that translate color into electrical impulses. These pulses are then transmitted via nerve endings to the brain, which interprets the information.

The eye contains two different types of cells: the rods and cones. The rods are used primarily for night vision, while the cones are used primarily during the day. When either the rods or the cones are dominant, it takes a few minutes to readjust. Usually this is not a problem and goes unnoticed. However, when you enter a movie theater from the bright sunlight, it often takes a few minutes for your rods to take over from the cones, making it very difficult to see clearly for the first few minutes in the theater.

COLOR BLINDNESS: DOES IT EXIST?

Many people believe they are color-blind. Actually, this is a popular misconception, as there is really no total color blindness. Rather, certain people have diminished color perception, which usually results in an inability to perceive certain portions of the visible spectrum accurately. Usually these deficiencies are transmitted through the x-chromosome, which explains why diminished color perception is more common in males.

There are three major forms of diminished color perception. The first type is called *protanopia*, which causes its victims to confuse red and orange with yellow and green. Then there is *deuteropia*, the inability to distinguish gray from purple—this is the most common form of diminished color perception. Finally, there is *tritanopia*, which leads to confusion of green with blue and of gray with violet.

Diminished color perception, in differing degrees of intensity, is very prevalent. Most people, however, are not aware of their own color aptitude. We often have no concept of how our perception of a certain color may differ from reality, or from what other people are seeing.

COLOR APTITUDE TESTS

People applying for a driver's license take a very rudimentary color test to see if they can distinguish red, green, and amber. Even if they cannot do this accurately, however, they can still get the license, since the lights on a traffic signal are always placed in the same sequence, allowing even the most color-deficient person to obey the traffic signal. But this test, and other common color tests, do not really determine a person's capability for making the very delicate and precise judgments necessary to produce an accurate four-color printed piece.

The best color-aptitude test on the market was originally developed by the Institute for Coatings Technologies, a trade association for people who match and mix ink pigments. The test consist of a series of 50 one-inch color swatches, which must be matched to a series of colors on a master board. When a match is found, the number on the back of the color swatch is written on the answer sheet. Differing weights are given to each answer so that the very best match may be awarded five points but other selections may receive three points, two points, and so on. These weighted answers make the test very accurate in detecting subtle differences between people's color aptitudes. (The test, known as the Fransworth-Munsell 100 Hue Test, is now marketed for the graphic arts community through the Graphic Arts Technical Foundation in Pittsburgh. It costs $595 for GATF members and $695 for nonmembers, and can be obtained from GATF, 4615 Forbes Avenue, Pittsburgh, PA 15213-3796.) There is also a companion test, called the Pseudo-Isochromatic Plates, in which the subject tries to distinguish an object from a series of colored dots. This test is less accurate than the Fransworth, but also costs less: $65 for GATF members, $85 for nonmembers.

When we first purchased our color-aptitude test at the Spectrum Color Center, we tested everyone in the plant. Not surprisingly, the very skilled color craftsmen did quite well. However, Ruth Hamilton, a young woman in the shipping department with no prior color experience, somehow managed to outperform the pros. Since she had no color background, I asked her if she ever knew that she had a natural color ability. She said that she had never thought about it, but as a child she had lived near her grandmother, who did needlepoint. Her grandmother always let the colored thread go down to its very end

A color aptitude test such as this gives an accurate assessment of color judgment.

before asking Ruth to go to the store for a new roll of thread. Although she had no sample to guide her, Ruth said she always returned with the correct color in hand. While not a scientific test of color judgment or aptitude, this yarn test shows an innate ability to recognize subtle differences between colors. As further genetic research is developed, perhaps we will discover which portion of which gene relates specifically to color aptitude.

As we age, we experience some decline in our ability to discern the subtle differences between colors. Also, illnesses can result in impaired color ability. For this reason, it is important to test people frequently, to determine their current abilities.

There is a common misconception that people know their own color aptitudes. People always tell me, "I see color very well, I know it." While this may or may not be true, our experience shows that one's own opinion can be highly suspect. We once hired a color scanner operator, 25 years old, who had been a scanner operator at a competing plant before coming to work for us. We were very busy and growing rapidly at the time and, in our haste, we failed to give him the standard color-aptitude test before putting him to work.

After a few weeks, we saw that all of his scans were seriously deficient. We thought that perhaps he needed more operator training, so we gave him extra tutoring, but a few weeks later his scans were still

seriously off-color, especially in the reds. This is when we discovered that we had failed to give him the color-aptitude test, so we then tested him once, twice, and even a third time. To our surprise, this young man, who had chosen color as his profession and had been active in the field for a number of years, was actually close to being color-blind. If he had not discovered until this test that he had such serious color deficiencies, how about the rest of us who also may erroneously believe that we see color far better than we actually do.

COLOR IS SUBJECTIVE

The biggest area of disagreement regarding color quality, however, occurs because color is a subjective phenomenon. The color I see and the color you see may be entirely different. Even if our eyes and color aptitude were identical, we still would not see color the same way, because our brain has more to do with the way we see color than our eyes do.

These differences come about because of life experiences. Our brain begins to take certain colors for granted and expects to see them. When this anticipated reality is not true, our brain can make it seem true. Thus, if we are accustomed to seeing a very magenta-blue sky, such as in the western part of the United States, our brains will tell us that we are seeing a very magenta-blue sky, even if we are actually looking at a grayer-blue eastern one. When

we look at brownish-green grass, we often mistakenly see the bright green grass that we "know" should be there.

This can be extremely dangerous and misleading when making color judgments—especially when you are making a comparison between a very small area in a 35mm transparency and the corresponding area on a large 8″ × 10″ color separation.

When trying to describe the subjective phenomenon of color, most people refer to the color wheel. The color wheel is divided into 10 sections, which represent ten different color *hues*. The colors are arranged on the wheel so that colors of similar hue (red and orange, for example) are placed next to each other. When two adjacent colors are used together, they blend successfully but don't provide much visual contrast. As you move along the color wheel, colors farther from each other will provide additional contrast. Most people agree that contrasting hues (those spaced three hues apart on the color wheel) work best together, since they have enough contrast to provide interest, but are not so glaring as the complementary colors (those opposite each other on the color wheel), which can contrast too much and actually disturb the eye.

We must also consider *saturation* and *brightness*. Saturation refers to the purity, richness, or intensity of color; brightness is the color's reflectance property such as light or dark. Most disagreements regarding color refer to purer versus more contaminated color (a saturation problem) or lighter versus darker shade of a color (a brightness problem).

THE ADJACENCY EFFECT

Another factor influencing color perception is *the adjacency effect*. When one color is placed next to another, the color or shade of the first will influence the perception of the second. Many print buyers experience this phenomenon when they make a color judgment on an isolated color separation and then, after the job is stripped with type and tint elements in position, are disappointed with the look of the same separation.

There is really nothing that can be done to compensate for color subjectivity, nor is there really anything you can do to compensate for your own visual color deficiencies—these will always plague anyone involved in the color business. There is, however, one factor affecting color that can be controlled: light.

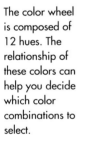

The color wheel is composed of 12 hues. The relationship of these colors can help you decide which color combinations to select.

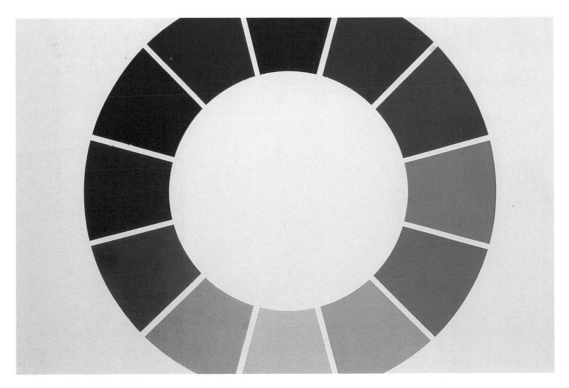

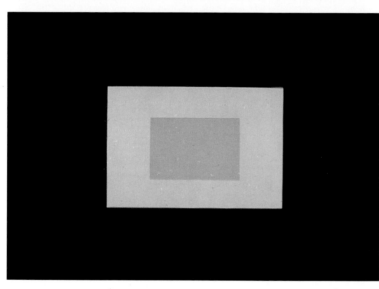

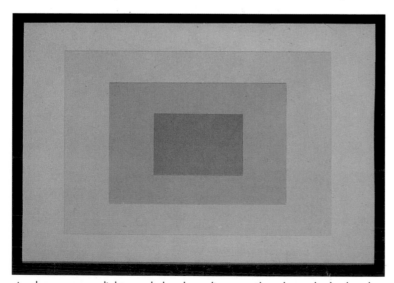

A color can appear lighter or darker depending upon the color or shade placed next to it. Thus, although the rectangle is the same in all three of these images, the center rectangle appears lightest when placed next to lighter shades. (Courtesy of Spectrum, Inc., Golden, CO)

COLOR AND LIGHTING CONDITIONS

All color is the reflection of light. For this reason, the light in which you view any color will directly effect your ability to make accurate color judgments. For this reason, the printing industry has adopted the 5000-degrees-Kelvin lighting standard developed by the American National Standards Institute (ANSI).

Kelvin is a physics term referring to light output. 5000K was selected because it is a mean between daylight and incandescent light. This means that an object under 5000K lighting is appearing under a compromise situation that attempts to approximate the middle range of the visible spectrum. Therefore, color that looks good under 5000K light will look acceptable under most lighting conditions.

To ensure good color communication, everyone in the color-printing chain, including the print buyer, photographer, color separator, and printer must be looking at their materials under 5000K illumination. If anyone along the line fails to conform to these requircments, the ability to achieve a quality product is greatly impaired.

To set up an appropriate viewing area, you need to either purchase a standard viewing booth or construct your own. There are several manufacturers of viewing booths. These structures resemble telephone booths and cost somewhere around $1,500. Portable booths, which are not as easy to use but have the added benefit of allowing different people in different departments to use the viewer, are also available, usually for about $600.

Those who wish to avoid these sizable investments, however, can construct their own viewing areas. Here's how to do it:

1. You will need a good light box with 5000K lighting. GE Chroma 50 fluorescent tubes work well and there is a comparable Sylvania product. The light box will cost about $200, and is available in various shapes and sizes from art supply stores or graphic arts dealers. The reason for the GE tubes is that many fluorescent lamps have the wrong color temperature. In addition, many suffer from a discontinuous spectrum, meaning that the lamp's spectral output is not uniform for all colors—although the lamp's light

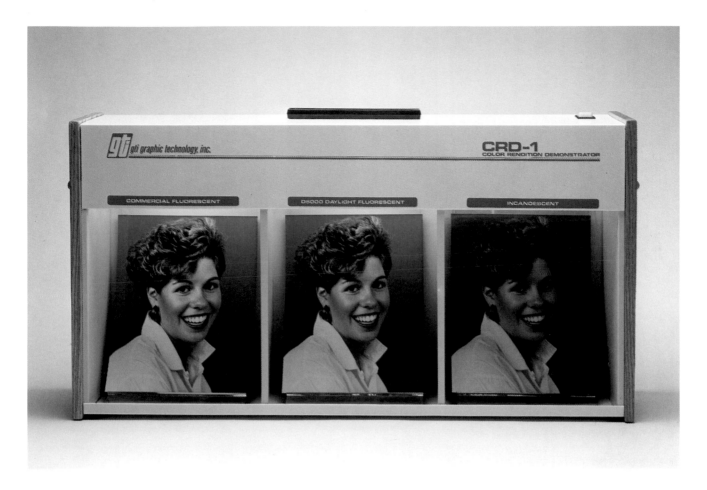

COMMERCIAL FLUORESCENT D5000 DAYLIGHT FLUORESCENT INCANDESCENT

Here, the same image is viewed under three different lighting conditions. Note how the image changes depending upon the light source. (Courtesy of GTI Graphic Technology, Inc.)

appears white to the human eye, in fact it may be producing too much blue and not enough red. The GE Chroma 50s produce a continuous spectrum and are balanced to produce light consistently at 5000K.

2. The second element should be an overhead fluorescent lighting fixture fitted with 5000K tubes. You need both the light box *and* the overhead lighting fixture because there are two ways to view objects—by transmitted light or reflected light. We view transparencies and slides by transmitted light, which necessitates the light box. We view prepress proofs, artwork, and press sheets, however, by reflected light, and therefore we need the same 5000K lighting in our overhead fixture as in our light box.

3. The third element should be walls painted a neutral gray. The color we perceive any object to be is affected by the color adjacent to it, so we need a neutral color surrounding our viewing area in order to avoid inaccuracies caused by the surrounding tones.

After constructing or purchasing your viewing area, use it at all times when judging originals for reproduction, prepress proofs, and press sheets. Be sure to change the tubes in both the light box and the overhead fixture every three to six months, so that the natural aging of the tubes will not distort your perception.

Some people argue that their readers, when looking at a printed piece, will not be looking at it under 5000K illumination, thereby making a specialized viewing area a waste of time. It is true that we cannot control where our readers will see our printed materials—one of print's best attributes is that it is portable and can be seen anywhere, and we never know if someone will look at our magazine, catalog, or book on a sunny day outside or in a poorly lit office. Remember, though, that if something looks good under 5000K light, it will look acceptable under almost *all* lighting conditions. Also, in order to maintain quality throughout the various steps in the color-reproduction chain we must be able to talk accurately to each other about color. This means a

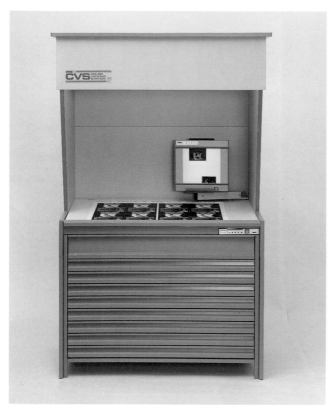

A viewing booth is an essential element in quality color reproduction. You can either purchase one from a graphic arts dealer or construct your own. (Courtesy of GTI Graphic Technology, Inc.)

When everyone in the production chain looks at their materials under 5000K lighting, there is clear color communication, which results in a better quality job. (Courtesy of GTI Graphic Technology, Inc.)

standard is necessary, especially given the subjectivity and other problems inherent in color, and 5000K gives us that standard.

(The full details regarding all of the parameters of the lighting standard are available from the ANSI, 1430 Broadway, New York, NY 10018. They have publications directed at applying the standard to transparencies as well as to final printed and proofing materials. When writing, request materials relating to standards PH2.31 and PH2.32. In addition, Rhem Graphic Controls has a graphic arts light selector for color viewing. It consists of two magenta color patches placed side by side. When the two patches are held next to a light source, they will appear identical if the light source is at the 5000K standard or different if the light source is incorrect for graphic arts viewing. This type of light selector can be obtained from a graphic arts dealer or directly from Rhem, 96 Glenmont Drive, Rochester, New York 14617.)

2 PRINTING IN COLOR

LETTERPRESS, GRAVURE, AND OFFSET PRINTING

There are three major printing processes in the world. The oldest form of printing is *letterpress*, first used in the fifteenth century by Gensfleischzum Gutenberg. Letterpress is a relief process requiring a raised metal plate. The raised area accepts ink and prints it when pressed on paper; the area that is recessed does not print. Letterpress was the predominant form of printing until the 1950s. In fact, had Gutenberg walked into a printing plant prior to 1955, he would have felt quite comfortable, for the industry had not changed very much despite hundreds of years.

Letterpress effectively died because it is expensive. Creating raised metal plates is costly, and letterpress requires more expensive papers to achieve the same results that can be obtained with cheaper paper on an offset press. Finally, letterpress presses run slower than offset web presses, adding again to the cost. Today, letterpress is used mainly for special-purpose imprinting jobs or jobs requiring embossing, hot-foil blocking, cutting, or perforating.

The fastest rising form of printing in the United States is *gravure*, which works on the opposite principle from letterpress. It uses an intaglio process—this means the printing area is recessed, rather than raised as in letterpress. A given image is

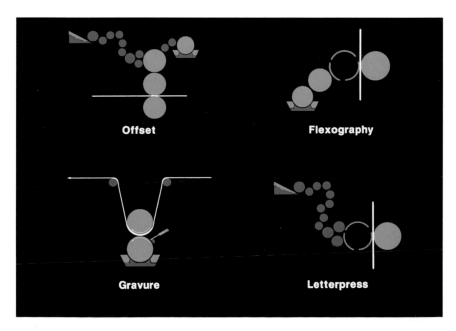

Offset

Flexography

Gravure

Letterpress

The four major printing processes are offset, gravure, flexography, and letterpress. Of these, offset has by far the largest share of the market. (Courtesy of Du Pont Printing and Publishing)

converted into cells, which are engraved onto a copper cylinder. In the printing process, the cells fill with ink, and the varying cells depths produce differing ink-dot sizes on the printed sheet.

Gravure printing is growing in popularity because although up-front costs are high, the process allows the use of lighter, less expensive paper, which can save money in the long run. These lighter-weight papers also result in postal savings, which can be considerable on long-run jobs. In addition, gravure offers more consistent color than offset printing.

The predominant printing process in the United States is *offset printing*, also known as *lithography*. It is a planographic printing process relying on neither a raised nor a recessed surface. Instead, offset printing uses the principle that oil and water do not mix. Part of the offset printing plate is sensitized. The sensitized area is referred to as *oleophylic*, which means that it

In letterpress printing, a raised metal surface on the printing plate contains the printing information, which is transferred to the paper. (Courtesy of Eastman Kodak Company)

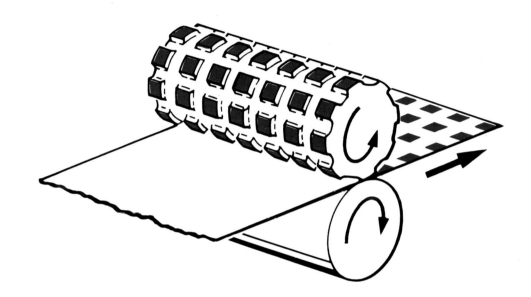

Gravure images are etched into a copper cylinder, so that the etched recessed area contains the printing information. (Courtesy of Eastman Kodak Company)

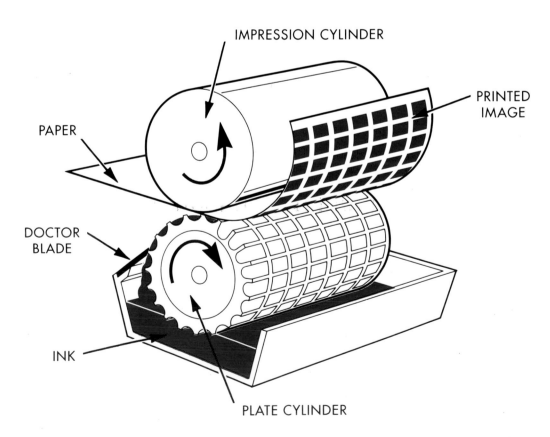

IMPRESSION CYLINDER

PRINTED IMAGE

PAPER

DOCTOR BLADE

INK

PLATE CYLINDER

The engraving of copper cylinders is a costly procedure, making gravure practical only for long-run print jobs. (Courtesy of World Color Press, Inc.)

will accept grease or oil (or, as it happens, printing ink), and the nonsensitized area is termed *hydrophilic*, which means that it accepts water but not grease. Thus, the non-sensitized plate area will not accept ink and therefore will not print.

The consistency of offset printing is always a problem. The greatest challenge to the printer is keeping color consistent throughout the print run. Today's computerized inking systems have come a long way, but the inconsistencies of offset printing are still very frustrating to any print buyer.

Then why is offset printing so overwhelmingly popular? Because it is so inexpensive when compared to any other methods. The relatively low up-front costs for film preparation and for operating the press itself make offset printing the logical choice for any

but long-run or specialized printing jobs. Print buyers could never even think of using four-color printing for short-run jobs, such as small-circulation magazines, if not for the economies of offset printing.

SHEETFED AND WEB

There are two different types of offset printing presses: sheetfed and web. These two different presses are used for different types of jobs.

Sheetfed presses are the smaller type. The paper for a sheetfed press is cut to a specified size at the paper mill and arrives in sheets, which are then fed into the press. This allows greater control of the working part of the press but is usually more expensive than web printing, because the precut paper keeps the press from operating at very high speeds.

Sheetfed presses can range from the single-color presses at "quick-print" shops to large four-, five-, or six-color presses that can print up to a 60-inch sheet. The sheetfed presses used on four-color jobs often feature the more complex five- or six-color capabilities. Some sheetfed presses can print on both sides of the sheet simultaneously—these are known as perfecting presses.

Web printing presses, on the other hand, use paper that arrives from the mill in rolls (or "webs"). The paper is fed into the press in one continuous feed, allowing the press to run at top speed and print both

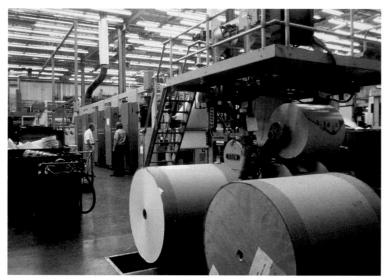

In web offset printing, paper is fed into the press on large rolls and is trimmed at the finishing end of the press. This makes web printing more economical for long print runs. (Courtesy of 3M Printing and Publishing Systems Division)

Major web printing companies today are innovating the finishing end of their operations at a rapid pace. Binding, ink-jetting, and mailing have become primary concerns.

sides at the same time. The paper is then trimmed to proper size at the back end of the press, after it has been imprinted.

The "make-ready" time—the time it takes to adjust the press so it can run at top speeds—is longer on a web than on a sheetfed press. Also, it is more difficult to control a web printing press once it starts a job, and so most experts agree that web presses do not produce as high-quality a job as sheetfed presses. Some excellent catalogs and magazines are printed on web presses, but only after paying for on-press quality-control measures and select top-grade paper.

Most web presses are heat-set. This means they have drying systems built into the press that dry the ink as soon as it is applied, producing a much higher quality job. Heat-set web presses usually print catalogs, better-quality inserts, and magazines, and are manufactured to conform to the 8½-by-11-inch size of most of these projects. They usually print in either 16-, 32- or 64-page combinations.

DOTS: SOLIDS, TINTS, AND HALFTONES

All printing inks are applied in the form of dots, which range in value (and size) from 1 to 100 percent. The size of a dot relative to the surrounding white space on which it is applied determines how we perceive a printed image. For instance, an entire page of 100 percent black dots would simply be solid black; an entire page of 50 percent black dots would be gray. The reality, of course, is that most images, once they are screened into dot form, reproduce as complex arrangements of dots of various values. It is the interrelationship of these dots that "tricks" our eyes into thinking we are seeing a continuous tone. To get a better idea of this, take a close look, preferably with a magnifying glass, at any photograph appearing in your local newspaper—you'll see that the image is in fact made up of nothing but dots of various sizes.

Printing in the form of dots basically offers three ways for something to be printed. First, an image can appear as a *solid*. This means it is formed by a 100 percent printing dot and no underlying white space. This is commonly referred to as line work. The biggest use of line work in offset printing is type, which is most readable in offset printing because it is

100 percent ink with no screen breaking it up. (In gravure printing, on the other hand, all portions of the printing plate must be screened, and thus type cannot print as a solid. For this reason, despite the many benefits of gravure printing, gravure type quality is just not equal to that of offset printing.) If you wonder whether something was printed by offset or by gravure, examine the type through a magnifying glass. If the type is solid, you know it was printed offset; if it is screened, it is either a mistake or was printed gravure.

The second offset printing method is through a *screen* or a *tint*. In this technique, the area to be printed will be screened to less than 100 percent of the printing dot size. There is a uniform dot-to-white-space ratio, however, creating a uniform shade of gray which, in colors other than black, translates to a wide range of tint colors. For instance, a 40-percent magenta tint might appear to be a pale pink; 30-percent magenta would be paler still; 50-percent cyan might approximate the blue we see in the sky; and so on. Various combinations of tints allow even more possibilities. Originally, contact screens were the only way to produce screens or tints, which were limited to 10-percent or 5-percent increments. Today's computer-generated tints, however, permit an infinite variety of colors by allowing tint adjustment within 1-percent increments. In the hands of a skilled designer, this provides enormous flexibility in creating colored type, or backgrounds, logos, and so forth. Remember, however, that colors created by tints are not pure or "flat" colors—they are combinations of the process colors and white space, which the eye perceives as the specified color.

THE PANTONE MATCHING SYSTEM®*

Most screened colors attempt to duplicate the colors in the standard PANTONE book from the *PANTONE MATCHING SYSTEM*, a technique developed in 1963 by Pantone, Inc. By ascribing a numerical value to each of hundreds of particular colors, and thereby effectively creating a standard color language, the PANTONE MATCHING SYSTEM makes color communication possible. Printing-ink manufacturers coordinate their pigments to match the colors in the

system, thus establishing uniformity and color quality throughout the industry.

To produce type, a logo, or a background in color on a four-color job, the easiest way to maintain uniformity is to request a specific PANTONE color. As just discussed, it is possible to create a screened color through a combination of tints, but by specifying this fifth, sixth or even a seventh color as a PANTONE number, the printer merely adds the specified ink color to an additional ink fountain on the press. The additional color is then printed as a 100-percent value of the additional ink. This assures you get the exact color specified. If the job is printed on a standard four-color press, however, it will need to be run through the press an additional time, adding considerably to the cost.

For this reason, despite the quality advantages of PANTONE colors, many designers simulate specific colors by using screens of yellow, magenta, cyan, and black. Unfortunately, only 30 percent of the PANTONE colors can be matched *exactly* using screens of the four process colors. Most colors, however, can be closely simulated to their PANTONE equivalents, and this will be sufficient for most printing purposes.

TINT-MATCHING GUIDES

With this in mind, it is wise to specify the desired screen combination for the printer. Simply telling the printer to "match PANTONE 369" will leave the color stripper to his or her own judgment in determining the best tint combination, leading to inconsistent colors. As you might imagine, this becomes a big problem when you want a consistent color to appear throughout various printed materials—you want to achieve impact through the consistent repeated use of certain colors, but this is impossible without clearly specifying your exact tint combinations for the printer.

Designers do not simply guess or estimate when specifying screen tints, of course—they consult tint-screen guides, which list the necessary screen recipes for achieving a wide variety of colors. The best such guide, called the PANTONE Process Color Simulator 747XR, contains the equivalent screen

The PANTONE Process Color Simulator 747XR lets you select from 747 ink colors, although only 30 percent of these colors can be exactly duplicated using screens of the four process colors. (PANTONE® is a registered trademark of Pantone, Inc.)

Many guides help you predict what color you will achieve by mixing certain screen tints. One of the most popular guides in the PANTONE Process Color Selector. (PANTONE® is a registered trademark of Pantone, Inc.)

combinations for all of the PANTONE colors and shows just how close each match can be.

Many printers and color separators also compile tint-build books for their customers. They represent, in book or chart form, the screened combinations used to approximate each of the PANTONE colors. These guides are usually free to customers but they are geared specifically to their respective printers and separators and therefore may not be appropriate for general use.

There are also commercial guides available. Many of these, however, are too small to be of major practical use. In selecting a color guide, see that the color samples or swatches are large enough so that

you can see the effect of one color when placed against another, or when adjacent to a four-color image. As discussed in Chapter 1, our impression of any color is influenced by the effect of surrounding and adjacent colors, so be sure to choose a guide that allows you to make this assessment.

Although most PANTONE colors can be simulated fairly accurately with process-color tints, some colors cannot be matched very closely. PANTONE metallics, for instance, require special inks, and therefore cannot be created from the four process colors. Also, some PANTONE colors are made up of components that include non-process colors, such as "warm-red," "reflex blue," or even simply white—

colors that include these elements cannot be simulated very well on a four-color job.

Remember that all printed materials are affected by light. Make sure, therefore, to keep all of these color-matching devices out of direct light except when they are in use, or else the colors in the guide will fade.

Pantone recommends that their guides be replaced yearly for this reason, which may be overly conservative and is somewhat expensive; it is nonetheless important to replace color-match guides at least once every two years, since constant use will cause color fading, regardless of light-free storage.

not justified by the very small color difference. (This caveat does not apply to electronically generated tints.)

3. When in doubt, always specify a slightly lighter screen value, especially when your job will be printed on a web press. All offset printing presses have a built-in dot gain factor. This means that the dot size on the film and on the printing plate will not be what appears on the printed page—especially for connecting dots (those over 50 percent value), there will be a widening of the dot, so that a 50 percent dot may, in fact, print as a 60 percent or even a 70 percent value. Even on a sheetfed press, although there is less dot gain, there is still a gain, so keep screens light.

4. When printing on a web press, make sure not to specify more than one solid (that is, more than one 100-percent value) in any screen build. Read the printer's spec sheet (see Chapter 11) and make sure that the specified screens are within the maximum density requirements for the printer's press. Ink-trapping problems (uneven ink distribution) can occur if there is too much ink in one particular area.

5. Designers often create a tint color by matching a particular portion of a four-color printed photo. To do this, merely circle the color you desire to match on the printed image. The stripper can then read the dot configuration in the circled area and provide that exact color.

6. The most difficult colors to create using process-color screens are the browns and beiges. Very dark browns, such as PMS 476, should be avoided since it requires very high-value screens and therefore can create trapping problems. Beiges require at least three (and often four) screens. If you must have a beige or a brown and cannot afford a fifth color on the press, try to substitute a black screen for the cyan. Since black is a noncolor, it is easier to control on press and offers a better chance of a closer, more consistent match.

THE HALFTONE PRINCIPLE

Continuous-tone images (i.e., nonline images, such as black-and-white photographs) are ultimately

produced on an offset press via the *halftone principle*. Under this system, images to be reproduced are photographed through a fine screen, which breaks up the image into a series of tiny dots of varying sizes. The dots range in value from 0 to 100 percent, with 0 percent representing white, 100 percent representing black, and the intervening values approximating the various shades of gray. Although a black-and-white halftone image is truly just black and white—black dots and white space—our eyes blend the dots into the illusion of a continuous tone complete with real-seeming grays.

In two-color printing, you can use a *duotone*, which represents two halftones, angled slightly to each other. Each of the halftones has some of the pictorial information, and together, they can add color and interest to a printed piece. Duotones present a challenge to the graphic designer, since it is difficult to visualize or simulate a finished duotone before the job goes to press. The ColorKey materials, manufactured by 3M, have the widest selection of overlays representing the PANTONE colors, thereby showing how a given color will combine with another

or with black, but they still do not manufacture all colors. Likewise, printers usually find it impractical to stock all of the colors available, since many are rarely used. They stock, therefore, the colors that are used most often. For this reason, the printer will often show a proof with black and another close color—one that they have in stock—rather than with the overlay color that will actually print, which they will obtain for the press run.

Black is usually specified as one of the duotone colors. Other combinations can be used successfully, but it is extremely difficult to predict the results of other combinations, so most designers shy away from duotones without black as the base color.

There are many guides published by paper manufacturers, as well as graphic design books, that can help you select duotone combinations. When you see something you like in one of these guides or in a magazine or brochure, show the picture to your printer. Merely describing the desired effect is often insufficient or inaccurate, but if you "show, don't tell," the printer has a much better chance of achieving exactly what you want.

Color separations are actually made up of four halftone screens, each one angled slightly to form a rosette pattern. (Courtesy of Du Pont Printing and Publishing)

1. 20% M, 60% C
2. 60% Y, 20% M
3. 45% Y, 60% M, 20% C
4. 70% Y, 20% C
5. 100% K

When producing a complicated piece of artwork, is better to present a keyline only and have the printer cut all the necessary screens.

LASER HALFTONES AND DUOTONES

Both halftones and duotones can be created on today's advanced color laser scanners. Many designers now choose to let their color separator produce these images, since the color possibilities from laser scanners are far better than what a process camera can produce. This is a good idea for high-quality work, but ordinarily single- and two-color budgets may not be able to accommodate the costs involved with laser scanning.

A color separator, however, can work successfully from a four-color original to create a halftone or duotone, whereas a printer must work from a continuous-tone black-and-white print. This makes it worthwhile to let the separator do the work when you only have color originals to work with, thereby avoiding the additional expense of conversion prints.

Producing good duotones is a skilled art. It takes a good eye and considerable skill to analyze a photo and see where the valuable pictorial information is stored. Photos can be classified as either "high-key" or "low-key," depending upon whether this important information is contained in the highlight or in the shadow portion of the picture. Again, providing the printer with a visual sample of what you are trying to achieve offers the best chance of obtaining the desired results.

SPLIT-INK FOUNTAIN TECHNIQUE

A specialized technique known as a *split-ink fountain* allows you to add color without creating any screens. In this technique, the on-press ink fountains are divided into various sections and the colors blend together in a rainbow effect, giving you the opportunity to have many colors on the page without the expense of halftone screening. There is little control over the printing, however, since there are no dots to control the ink coverage. For this reason, split-ink fountain jobs should be limited to projects that have short runs (under 1,000 impressions is best) and do not require a high degree of uniformity between the various impressions.

3 COLOR SEPARATIONS

Four-color printing, commonly referred to as process printing, is the highest form of the printer's art. Under this process, an original color image is screened four times—once for each of the process colors—creating four separate dot patterns that, when combined, give the illusion of the full-color original.

When the original image is screened, each screen is positioned at a slightly different angle. This causes the dots to interact in a *rosette pattern*, which gives the best illusion of the original. It is important to remember that the color separator cannot *duplicate* a continuous-tone image, such as a transparency or a piece of artwork. Rather, the color separator produces a rendering or representation of the original within the boundaries and limitations of the printing process. Because the rendering requires a great deal of interpretation and skill, the separator will often need guidance as to which portions of the original must be preserved and which areas, if any, can be somewhat distorted or adjusted.

Four-color printing uses the same principle as an Impressionist painting: The colored original is broken up into a series of dots, which the eye interprets as continuous tone. (Courtesy of Du Pont Printing and Publishing)

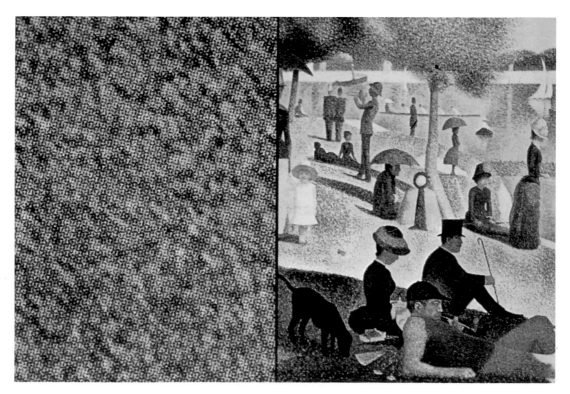

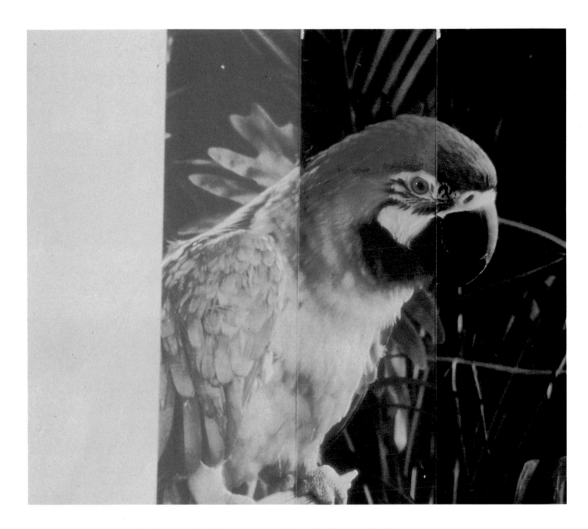

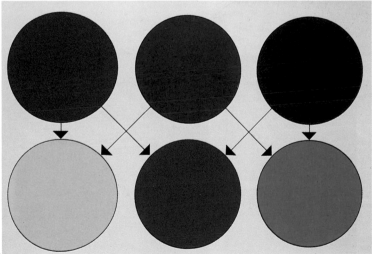

Above. When yellow, magenta, cyan, and black are combined, they reproduce almost every color in the rainbow. (Courtesy 3M Printing and Publishing Systems Division)

By filtering out one band of light and leaving the other two, the color separator transforms the additive colors of the original into the subtractive colors needed for printing.

As explained in Chapter 1, when we speak of the four colors in four-color printing, we refer to yellow, magenta, cyan, and black. Printers and separators often refer to these in a shorthand of single letters, as follows: *Y* for yellow; *M* for magenta; *C* for cyan; and *K* for black. Why *K*, instead of *B*, for black? To avoid confusing it with blue.

SUBTRACTIVE COLOR THEORY REVISITED

As explained in Chapter 1, four-color printing operates on the principles of subtractive color theory. To illustrate this, let's look at an example. Here we have a camel, known as Horace the Hump. Camels are normally brown but, for our purposes, Horace is

Horace the Hump is a camel. Camels are normally brown, but this one is composed of the three primary colors or light—red, green, and blue. Let's reproduce Horace. (Courtesy of Du Pont Printing and Publishing)

First, a blue filter removes the blue-light elements, leaving the green and red, producing the yellow negative. (Courtesy of Du Pont Printing and Publishing)

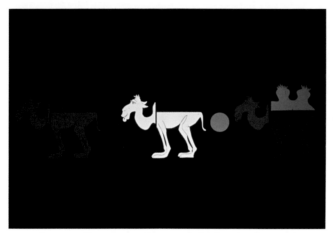

Next, the green filter removes the green-light elements, leaving the red and blue, producing the magenta negative. (Courtesy of Du Pont Printing and Publishing)

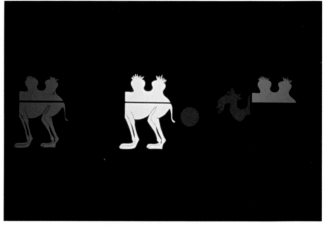

Finally, the red filter subtracts the red-light elements, leaving the blue and green and producing the cyan negative. (Courtesy of Du Pont Printing and Publishing)

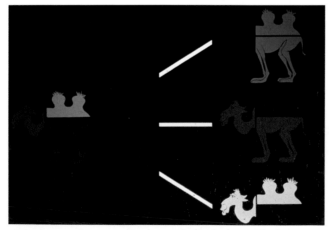

According to subtractive color theory, the combination of yellow, magenta, and cyan should reproduce the additive colors red, green, and blue. (Courtesy of Du Pont Printing and Publishing)

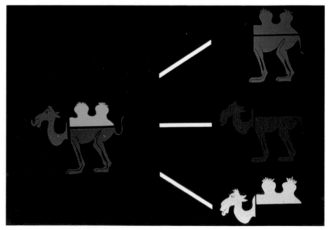

In reality, using ordinary printing inks, this combination does not yield a true red, green, or blue, but the muted colors shown here. (Courtesy of Du Pont Printing and Publishing)

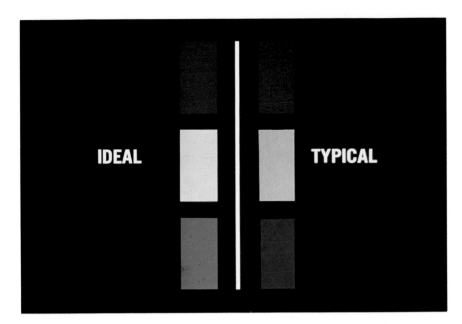

IDEAL **TYPICAL**

Ordinary printing inks do not directly correspond to subtractive color theory because of their inherent impurities. (Courtesy of Du Pont Printing and Publishing)

made up of the three primary colors of light; red, blue, and green.

Our task is to reproduce Horace, so we use a series of filters and photograph Horace through them. The red filter takes out the red light, leaving the blue and green and creating the cyan negative; the green filter takes out all the green-light areas, leaving the blue and red and creating the magenta negative; and the blue filter subtracts all the blue, leaving the green and red to create the yellow negative.

If color printing held true to subtractive color theory, Horace would be reproduced accurately. As shown on page 32, however, using ordinary printing inks, Horace does not reproduce true to color. All of his colors are washed out and dull. This is because of the inherent inaccuracies of printing inks (see Chapter 1). For this reason, color separators must always compensate for these deficiencies. Thus they typically reduce magenta in all blue-light areas, reduce yellow in all green-light areas, and reduce yellow in all red-light areas. Had this been done to Horace, he would have been reproduced properly.

DYES vs. PIGMENTS

Color buyers often question why inks are in the form of pigments rather than dyes. It is really just economics. If printing were done with dyes rather than pigments, the cost would be astronomical and almost no one would be able to print. A small 35mm transparency made up of dyes costs about 25 cents—consider what thousands or millions of copies of a printed piece would cost under this price scale! Printing-ink pigments, therefore, despite their inherent problems, do make color printing possible.

CHALLENGES FOR THE COLOR SEPARATOR

One of the major tasks of the color separator is compensating for the impurities of ink pigments. This process, known as color correction, can be done photographically (dry etching), chemically (dot etching), or electronically.

Most color-correction work today is done electronically. Color scanners, which assess each area of an image for the proper level of each of the four printing colors, have the ability to make overall color corrections or selective color corrections. Overall corrections can be very tricky, since these adjustments effect every part of the image where the adjusted color appears. Making an adjustment in the magenta, for instance, has implications for all the reds, purples, and oranges. Also, because magenta is used to provide shape and detail for the greens, the effect will be even more widespread.

Selective color correction is more complex and often involves masking so that only a particular image portion is affected. This is cumbersome and can therefore be costly.

While correcting color, the color separator will also be trying to maximize sharpness. Sharpness is the key to good color reproduction, since only a sharp image has crisp, clear color. One of the major advantages of electronic color scanners as compared with process cameras is that the scanners produce a far sharper image. Unlike a camera, a scanner is a point-by-point analysis device, so that each image segment is analyzed separately, resulting in a sharper appearance. Laser scanners are especially good at capturing and reproducing tiny details.

Scanners have many settings for achieving sharpness enhancement, a process known as *unsharp masking*. This process involves accentuating the contrast between adjacent tones, which gives the appearance of more detail. Selecting the proper unsharp masking setting is difficult: When too low a setting is chosen, the image appears dull, the colors washed out; when too sharp a setting is selected, tiny black lines appear around small detail areas, detracting from the reproduction.

The color separator is also concerned with selecting the proper *reproduction curve* for the job. The reproduction curve refers to the range of highlight through shadow dot densities needed to reproduce the subject properly. Color scanners are capable of bending or altering the reproduction curve. This allows the color separator to affect one area of the curve without altering the other portions. With this technique, the separator can open up shadows or correct highlights without affecting the rest of the image. This is particularly useful in making

Overall color changes, such as the corrections executed on these images, are relatively easy to achieve on color scanners. Selective corrections are more complicated and expensive. (Courtesy of Spectrum, Inc., Golden, CO)

The image on the right appears sharper because the unsharp masking process has been used to accentuate the adjacent background color.

overexposed or underexposed images appear as correctly exposed.

The wide value range in most color images makes it impossible to achieve exact reproduction throughout all areas of the picture. Therefore, the color separator must always select which portions of an image to reproduce most faithfully and which to sacrifice because of the limitations of the printing method. In a high-key image, where the most important pictorial information is in the highlight region, the operator may decide to increase highlight contrast, which will increase the highlight detail at the expense of detail in the shadow areas. The opposite technique may be desirable for a low-key image, where the most important information is in the shadow area. In this case, the operator may select to increase the shadow contrast by moving the midtone dot toward the shadow end of the scale. This will flatten the highlight detail, but will increase the detail and sharpness in the shadow area. For average (neither high- nor low-key) photos, the operator may alter the highlight, mid-highlight, midtone, midshadow, or shadow to produce the best results.

Color separators are also concerned with *gray balance*. The correct gray balance means that there is a proper combination of cyan, magenta, and yellow dots to produce the correct neutral gray scale. Because gray reflects what is happening with the other colors, the correct reproduction of grays helps ensure that the remainder of the image is color correct. The separator must also be alert to the color cast—an overall green, red, or blue hue—that sometimes afflicts original photography. The scanner operator can combat this problem by again achieving a proper gray balance. Since the grays are made up of yellow, magenta, and cyan, attaining a proper gray will result in proper color appearing throughout the image.

The color separator must also be alert to the presence of *moiré patterns* (or, simply, *moirés*), a natural outgrowth of the separation process. When the four color levels have been separated and converted into overlaying screens, the screens' dot arrangements combine to create a sort of shimmering, mottled pattern appearing over the image—this is the moiré pattern.

To combat this problem, printers create the four screens in an angled configuration. Standard screen angles are 45 degrees for the black screen, 75 degrees for the magenta, 90 degrees for the yellow, and 105

To run correctly on a printing press, an image must have a specific amount of yellow, magenta, and cyan dots in all neutral areas. This concept is known as gray balance.

To avoid moirés, the four process screens are angled slightly to each other.

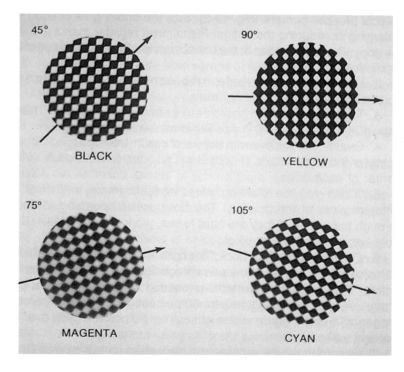

degrees for the cyan. This keeps the two most dominant colors, black and cyan, relatively far apart from each other, which helps to avoid moirés.

Angling the screens, however, is not sufficient to do away with moirés altogether. If the overlaying screens are even slightly out of register, a moiré can appear; fine-lined subjects, such as images of Venetian blinds or pinstripes, are particularly susceptible to moirés; and when separating previously printed materials, such as an image from a magazine, the image's original dots will conflict with the dots created in the

separation process, inevitably leading to a moiré.

The separator also employs the process of *undercolor removal* (UCR), which refers to the task of removing some magenta, yellow, and cyan from dark shadow areas and replacing them with black. This is needed to reduce high concentrations of ink buildup in shadow areas, which could lead to press problems, such as trapping. Also, creating a longer black range increases detail in these shadow areas. Each printer and press have different UCR requirements.

A HISTORY OF COLOR SEPARATION TECHNIQUES

The computerized color scanner opened up the world of color printing to a vast array of buyers who never would have thought of using color previously. Now almost everything is printed in color, including newspapers, small-circulation magazines, and even fliers of less than 1,000 copies.

Today, the color separation industry is evolving from a craft-dominated industry into a technology-driven industry. Previously, the quality of an

A laser scanner is actually an electronic-dot-generating scanner, since the laser device is only on the output end of the scanner, where the final halftone dots are created. (Courtesy of Spectrum, Inc., Golden, CO)

Rotary-drum scanners, first introduced in the 1970s, drastically changed the way color separations are produced. Today, 90 percent of all separations are produced on color scanning equipment. (Courtesy of Spectrum, Inc., Golden, CO)

individual color separation plant was tied to its ability to hire the best craftspeople who could do the intricate handwork involved; today's color separators can be distinguished by the equipment they use.

In the 1920s and 1930s, color was limited to calendar shots. Photoengraving (the letterpress equivalent of color separation) an individual calendar often took weeks of painstaking hand work to render just acceptable color. Backing up each cameraman were six to ten artists, who worked and reworked the films to produce an acceptable product.

In those two days, the process camera was the main piece of equipment and direct screening was the norm. In the direct-screening process, a series of filters was placed on the camera lens. Each filter blocked one band of light, left the other two, and thereby formed one of the subtractive colors. As we have seen with Horace the Hump, the colors achieved by these crude methods are not good, and the skilled retouching artists were therefore necessary to complete the project. Even the retouched color, however, would not satisfy today's color buyer. The long production times would also be unacceptable today. For example, if you walked into a photoengraving plant in 1935 and wanted a set of plates for an 8½-by-11-inch magazine cover with one color image plus tints, you would receive your plates in a month and it would cost you $1,000 (1935 dollars, at that). Today, the same job is routinely produced in less than a week, usually for no more than $500.

During the 1940s and 1950s, the craft techniques improved, but the basic equipment—the process camera—remained the same. To achieve a better product, indirect-screening methods were used. In this technique, continuous-tone films were produced, then color-correction masks were provided, and a combination of wet and dry etching took place. This method, however, involved a considerable amount of labor and materials. Dot etching, in particular, was (and is) very costly. Dot etching is the chemical enlargement or reduction of the printing-film dots in order to alter color. The dot etcher must be very skilled to make accurate judgments as to how much to alter the dots.

Once this judgment is made, the etcher uses a red opaque to "stage," or paint out, all areas *not* to be altered, exposing only the affected portion. Then the dot etcher applies a mixture of potassium ferracyanide and water to the exposed area with an artist's brush. The solution then begins to eat away at the film dots. Once this begins to take place, the etcher must hold a magnifying glass in one hand and a water hose in the other, so that the chemical reaction can be stopped as soon as the dot is altered sufficiently. If this is not done quickly enough, or if the etcher has misjudged what was needed, the tedious process must begin all over again.

Remember too that this same process often must be done on each of the four films and that the same chances for error exist each time. Also, the dot etcher will still not know the true effect of this work until the creation of a prepress proof. This time lag between when the work is completed by the etcher and when the results are available is further magnified if the proofs indicate that more etching is necessary.

As this description indicates, dot etching is cumbersome and expensive, and requires considerable years of practice to do correctly. It was, however, the best means of color correction during the prescanner years. As interest in full-color printing grew, there was a need for better methods to produce the films. Buyers in the 1960s were faced with a choice of accepting mediocre color from direct-screening methods or paying very high prices (in terms of both time and money) for good color created with considerable dot etching.

In the 1970s, however, a major breakthrough occurred. The computer was coming into widespread use and was introduced into the graphic arts industry in the form of the color scanner. A scanner differs drastically from a camera: While a camera can only do a single, overall analysis of a subject, a scanner records an image piece by piece, sampling each bit of pictorial data. Because of this increased flexibility, the scanner can execute masking, color separating, and screening in one step, reducing turnaround times, increasing quality, and lowering costs. For this reason, the vast majority of today's color separations are produced on color scanning equipment.

COLOR SCANNERS: WHAT THEY ARE AND HOW THEY WORK

Scanners are manufactured by a few large multinational companies. Most scanners in the United States are made by the Hell corporation in Germany. The second major manufacturer is Crosfield, a British firm now owned by Du Pont. The Japanese company DS America is also a major manufacturer and Scitex, an Israeli company, best known for its color electronic prepress systems, has sold color scanners as well.

Most scanners operate similarly. First, an original image (usually a transparency) is placed on the outside of a transparent rotary drum, which begins to spin. An analyzing beam of light is then directed down an optical path to the rotating drum, where it is deflected by a mirror and illuminates the image on the drum. The illuminated image is then electronically analyzed and split into four light paths via filters. Each band of light passes through a photomultiplier, three of which are equipped with red, green, and blue separation filters and the fourth of which has a signal for unsharp masking. The black signal is produced from information from the other three color signals.

Meanwhile, unexposed output film is mounted on a separate recording drum in a light-free environment. This drum rotates in concert with the input drum. As the original image is analyzed and electronically separated into distinct computerized signals, these signals are in turn converted into an output signal, which the computer uses to reproduce the image in screened-dot form on the output film, all in the proper reduction or enlargement percentage specified by the scanner operator. The dot produced with a laser scanner is called a *micro dot*, which combines with other micro dots to form one halftone dot. An individual printing dot can be composed of as many as 144 different small pulses.

Today, scanners can produce all four separation films with one pass on one sheet of film, depending on image size and film size. Modern versions allow the operator to see the results of corrections on a video screen rather than solely through densitometer readings, as on older scanning devices.

Color scanners are point-by-point analysis devices that transform light into electronic signals. (Courtesy of Eastman Kodak Company)

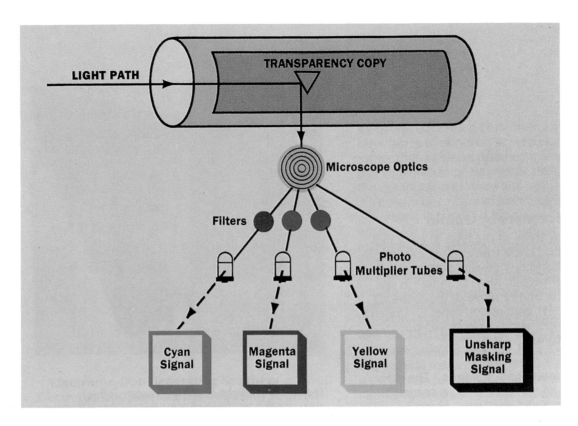

Below. GCR stands for gray component replacement. You can incorporate various amounts of GCR into your separations to achieve better color printing. (Courtesy of Du Pont Printing and Publishing)

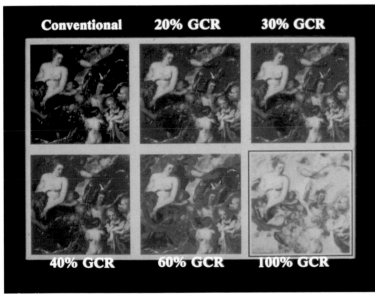

GRAY COMPONENT REPLACEMENT

Gray component replacement, or *GCR*, is one of the hot topics that appear periodically in the graphic arts industry. Currently, there is a resurgence of interest in GCR because there are now scanner programs that can simulate the GCR techniques achieved earlier by craft methods.

The major portion of the picture data in ordinary scanning is contained in the three subtrative colors.

In GCR, however, the black plays a more significant role. The black is used to replace the third or tertiary hue in each color. Most printed colors rely upon two of the three process colors to achieve the color we see on the page; the third or tertiary color is usually a minor player, used only to neutralize the tone and provide depth and detail. In GCR separations, this tertiary color is replaced with the neutral color black, making printing easier and saving ink, especially on high-speed web presses.

GCR makes it easier to reproduce certain colors, especially when key colors, such as purples, reds, or greens, run next to each other on the press. Red, for example, is traditionally created with large amounts of magenta and yellow and a small amount of cyan, and green traditionally contains high concentrations of cyan and yellow and a lesser amount of magenta. When an image of, say, a red dress appears on the press in front of a green landscape scene, there is little latitude for increasing the amount of magenta or yellow in the dress, because this would contaminate the grass color in the landscape image. With GCR, however, black can substitute for cyan when making red, and for magenta when creating green, leading to fewer color conflicts.

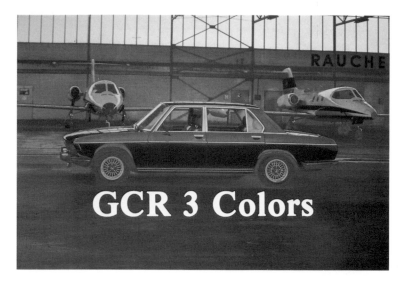

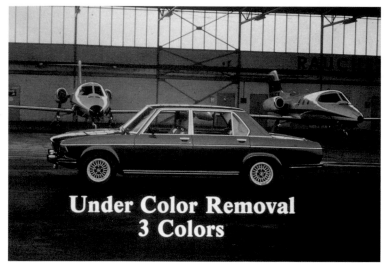

When three process colors (all but black) are printed, note the differences between a standard color separation, a separation with heavy undercolor removal, and a separation with heavy gray component replacement. When the black is added, all three separations will look identical. (Courtesy of Du Pont Printing and Publishing)

The amount or extent of GCR can vary. At 100 percent GCR, all of the minor color is replaced with black, but this generally causes printing problems, so 70 to 80 percent GCR is more common. In the case of creating red, for instance, this means that 70 to 80 percent of the cyan element is replaced by black, with the remainder staying as cyan.

A printer and separator must work very closely to determine the proper GCR mix for a job. This is complicated by the fact that scanner manufacturers do not employ consistent GCR standards, meaning that 50 percent GCR on one scanner may not equal 50 percent on another. Unfortunately, the only way to determine the optimum GCR mix is by trial and error, which is probably not what you had in mind for your job.

Also, most printers have not realized the ink savings that were originally promised from GCR. When first touted, GCR was said to reduce ink costs drastically because black ink is less expensive than colored inks. The problem however, is that printers had been using inexpensive black ink because it was needed primarily for type—with black playing more of a role in color images, it is necessary to use a better, more expensive black, thus negating most of the cost savings. Also, because the technique requires additional programming to achieve the correct GCR curve, many color separators charge an additional premium for producing GCR separations.

Deep, rich colors usually look better with GCR, but pastels suffer. Too much GCR can make colors look weak, and the overabundance of black can lead to a dirty appearance. Neutral areas of black or gray, on the other hand, do have a greater degree of consistency, even during long press runs.

Thus, the debate rages as to whether GCR is better or worse for overall color, price, and consistency. To help answer the question for yourself, it is wise to consult with your color separator and your printer, together. They should determine if GCR is proper for your job, if they feel comfortable in creating and running your film in this manner, and if they have enough experience to do your job right. Keep your options open.

4 SELECTING AND WORKING WITH A COLOR SEPARATOR

PLANNING A FOUR-COLOR PROJECT

The typical four-color job involves coordinating many complex elements. As a designer and/or production manager, you will need to plan a strategy for reaching your goal, which usually involves a scheduled deadline. This date, usually set by your client, can either be the final delivery day or, in the case of a direct-mail piece, the date the printed piece is to be put in the mail.

Good planners are worth their weight in gold. I have often felt that only half of the money spent on producing a four-color project is actually spent on necessary goods and services, while the other half is often wasted—usually on overtime charges, foolish mistakes, and so on. The culprit behind this wasted time and effort is the rush job. Use your money wisely by planning ahead and avoiding last-minute work.

To plan effectively, spend time up front listing all the tasks that will be involved in your project. Figure 4–1 shows such a listing for a large catalog project. Proceed backwards from your deadline. Now assign one person to be responsible for each of these tasks.

Before beginning a four-color project, spend some up-front time planning. Consider all possibilities and make sure you have "air" in the schedule. (Courtesy of 3M Printing and Publishing Systems Division)

STEPS OF CATALOG PRODUCTION

- Production can be accomplished within a realistic, efficient schedule and within budget.
- Production can be accomplished within a compressed schedule, usually resulting in budget excesses due to rush and overtime charges.
- Production *can* be accomplished with disregard for schedule and disregard for these necessary and logical steps; however, such disregard will ALWAYS result in budget excesses as well as loss of good will among the client and/or the project coordinator and/or the suppliers.

An unforgiving amount of time is required for each of the following steps:

6. Proofing and Corrections

5. Typesetting/ Photography/Duping and Assembly

4. Design and Copy

- Design is too often shortchanged. It is the stage at which all mechanical nuances and problems should be addressed and solved:

3. Product Allocation and Format Development

- Product allocation provides a schematic layout of the catalog and serves as a blueprint for everyone involved in the marketing and production efforts. It is

2. Product Selection

- Product selection is the first opportunity for "slippage" within the schedule. No further step can be taken until the product list is supplied.

1. Scheduling

- The tight production schedule is based on a thorough knowledge of each phase of production and the time requirements of each phase.

- The time requirement for each phase of production is directly related to the number of pages to be produced.

4-1. This step-by-step sequence shows the many tasks necessary in the planning of a four-color project. (Courtesy of Joe Corbell Design & Production, Cheyenne, WY)

BINGO!

12. Mailing

11. Printing and Bindery

- Changes are more costly at this step than at any previous step.

10. Proofing of Engraver's Proofs

- *Changes to copy and layout at this stage are disastrous, to both schedule and budget!*

9. Color Separation and Stripping

- It is important that the engraver receive assemblies *and* mechanicals at the same time.

8. Proofing of Mechanicals and Assemblies

- If all previous steps have been properly executed, this should be one of the easiest.
 1) Is copy with the correct product?
 2) Were the previous typographic corrections made?
 3) Were any typographic errors missed?
 4) Are all glyphs, callouts, rules, etc. included?

7. Mechanicals

- The mechanicals are executed on the basis of the approved layouts, photography, and corrected type.

- The proofing of typeset galleys should be for typographic correctness and not for copy rewrites or fine-tuning of previously approved copy.

- These production functions can be executed simultaneously on the basis of previously approved layout and copy.

1) Exact sizing of products
2) Copy fitting
3) Exact locations and sizing of glyphs, callouts, etc.
4) Considerations of color breaks.

- It is important that the merchandising personnel know how to "read" a pencil layout.
- Copy should be written on the basis of, and coincidentally with, the layouts

and should be given full and proper consideration at this stage. Once approved, it should be considered final and read only for typographic correctness beyond this step.

an opportunity to evaluate product mix and product flow and to move product within the book, page to page, without impacting the more critical later steps.

- Format development establishes the graphic parameters for the catalog, providing a concise graphic look of the design objectives and nuances.

- The decisions made at this step should be based on the purposeful consideration of all responsible parties and should be considered *final*.

- The schedule should always allow maximum flexibility for the client while accommodating efficiencies, economies, and optimizing production quality.

4-2. This planning calendar illustrates an important concept in project planning: Always start planning from your end date and work backwards to see when you need to start earlier phases of the project. (Courtesy of Spectrum, Inc., Golden, CO)

DATE — M T W TH F | M T W TH F | M T W TH F | M T W TH F | M T

PRINTING/MAILING
- Mail drop
- Lettershop
- Bindery
- Job on press/press check
- Approve revised bluelines
- Approve/correct bluelines
- Materials to printer

SEPARATIONS
- Final film
- Compose final film
- Approve/correct color
- First proofs
- Printer's spec sheet to Spectrum
- Materials to Spectrum

LAYOUT/MECHANICALS
- Approve final mechanicals
- Mechanical production
- Approve final concept
- marketing
- legal
- design
- traffic
- packaging
- Working layout

TYPESETTING
- Final galleys due
- Proofread galleys
- First galleys due
- Copy to typesetter
- Spec copy

COPYWRITING
- Final draft due
- Revisions to copywriter
- First draft due

ILLUSTRATION
- Create charts/graphs
- Create illustrations

PHOTOGRAPHY
- Stat final photos
- Final photo selection
- Review photos
- Photoshoot
- Assemble props/hire models/stylist
- Schedule photoshoot

SELECT PREP/PRINT VENDORS
- Final selections
- Bid out printing
- Bid out color separation

CONCEPT
- Set overall budget
- Select copywriter
- Select photographer/illustrator
- Initial concept approval
- marketing
- legal
- design
- traffic
- packaging
- Create roughs
- Develop ideas
- Establish objectives/parameters

Ask them how long they will take to complete their work, and then ask them to sign off on a schedule reflecting their assessments. A signed commitment goes a long way toward ensuring success.

Now construct some sort of visual device so you can easily see the task at hand. Figure 4–2 is a planning calendar developed by Spectrum. It starts with the mail date and divides the various tasks involved into broad groupings, such as *Printing/ Mailing*, *Separations*, *Layout/Mechanicals*, and so forth, with several specific tasks within each grouping. Your job may or may not have as many components, but this list is a starting point for developing a schedule of your own.

In deciding how much time to allow for each task, always budget at least 10 percent more time than you initially feel is necessary (or even more if your company or staff is particularly disorganized), since delays and problems will inevitably occur. It is impossible to plan such a complex task as a four-color project without accounting for these problems.

Somewhere on your visual guide you should have, in bold type, the end date. This will keep you and everyone involved in the project focused, and will help to keep things in proper perspective. Many of the initial tasks on a project are creative, and the creative process, if not held in check, can take forever, since any job could always be refined a little more or done a little differently. Keeping the end date in mind, even at the early stages, is a good way to avoid delays that could ripple throughout the rest of the schedule.

CHOOSING THE RIGHT COLOR VENDOR

Today's high-tech color world requires that you thoroughly investigate prospective color separation vendors to see if they can meet your needs—not only today, but also in the future. In the past, you would contact local vendors and select a firm based on its reputation or because it submitted the lowest bid; today, you must do more research. Various companies specialize in different types of color work and have purchased equipment specifically geared to these types of projects. If you want to get the best value, you should match your needs to those of appropriate vendors.

unsure of exactly when you will be submitting camera-ready art, at least give the separator a general idea, so that a rough schedule can be drafted. Make sure that the turnaround requirements of the job are part of the quote, so that the separator cannot later claim that your normal turnaround intervals constitute a "rush."

COLOR SEPARATION PRICING

Most color separators base their pricing on three factors. First is the size of the film produced—you will pay more for a large separation than for a smaller one. Next is the type of input copy—you will usually pay less for a separation when transparencies are submitted rather than original reflective art. Finally, there is the time given to complete the job—the rush job will always add substantially to your cost. Since a rush job also has the greatest chance for mistakes, which can further inflate costs, avoid such jobs whenever possible.

Traditionally, the separations themselves were priced according to a simple rate sheet, with the subsequent stripping or film assembly, involving endless variations of labor and materials, handled on a job-by-job basis. This is becoming somewhat less

significant because of electronics, but film-assembly costs still must be examined carefully to understand and evaluate a bid.

STRIPPING COSTS

Stripping is a printing term for film assembly. It involves positioning the film for all elements on a given page in their final positions. For instance, a page may have three color images, some text type, and a background tint—each of these is first shot, separated, or created individually, on separate pieces of film, which then must be stripped into the elements' appropriate page positions.

In traditional hand stripping, each separation is first priced according to the parameters just described (i.e., according to size, transparency vs. reflective, and so on). Then, for each four-color image, there is an accompanying cost for stripping the image into position. The least expensive positioning cost is for a square-cut image on a white background. If you need to *butt-fit* an image (place it directly against another) or *inset* one image within another, the costs are doubled. Also, if an image needs to be *outlined*, *silhouetted*, or *dropped out* to white, there are additional charges for cutting the necessary mask.

Mechanical stripping is a demanding trade that requires a high degree of precision. (Courtesy of Spectrum, Inc., Golden, CO)

These charges can be relatively low for simple square cut masks, or very expensive for very complicated intricate masking (such as around bicycle spokes or hair).

Type is considered next. The least expensive is black type overprinting an image or printing directly on white paper—this only requires a line shot. If, however, you wish to print your type in white on a colored background on an image (also called *reverse* or a *knockout*), this requires the stripper to first make a line shot and then create a reverse negative to knock out the type, which is more costly. Also, if the type is coming out of a four-color area, there is a risk of misregistered film, so the stripper will compress the type slightly and enlarge the image area a little, to ensure that the two elements will fit snugly once the job is printed. This process, referred to as *trapping*, also costs more.

If you want your type in a color other than black or white, additional money will be involved for the stripper to position tint negatives for the type. Each tint negative needed (red type would need two, for example—yellow and magenta) adds to the cost. And if the colored type is printing on a four-color element, the above procedures for reverse type must first be done before the tint negatives are stripped into place. This can add significantly to the overall cost.

Sometimes tints are used for other purposes, such as creating a background color (see Chapter 2). The same procedures must be followed for stripping in the tint screens, adding to the price.

After all elements have been stripped up, they still must be composed into four sheets of composite film. The individual pieces of the preparatory work are known as *working films*, and the final four pieces of film, with all elements compressed into proper position, are variously known as *final films*, *composite films*, *stripped films* or *plate-ready films*.

Clearly, hand stripping is a labor- and materials-intensive procedure. In general, each additional individual piece of film needed has a corresponding labor task, both of which factor into the final bill. This is why an individual four-color 8½-by-11-inch ad can vary widely in cost, from $300 to $1,000 or more per page.

ELECTRONIC ASSEMBLY COSTS

With the advent of electronic prepress systems, the labor and materials of hand stripping are replaced by a machine. Costs are based on how much machine time is needed to complete the task—with electronic systems often costing over $1 million, time on the system becomes the significant factor.

Separators using these systems will still be concerned with the number of images in a job, because it takes time to scan each image and position it on the page. They are particularly conscious of the time it takes to outline an image—outlining on electronic systems takes as much time as it does by hand, a significant issue when a piece of equipment with hourly operating costs of $200 to $500 is doing the outlining.

Tints, however, are easily created on electronic systems, so the modern separator is less concerned with how many tints you are using, whether in type or for other purposes. Electronically created tints are extremely accurate within 1-percent increments, and can be made very quickly. In addition, electronic systems create perfect traps quickly and easily (unlike the more imprecise hand-stripping methods), so that films created electronically look very good.

For these reasons, it is a good rule of thumb that if your job involves complicated tint stripping and more than three four-color elements on a page, you will get a far better price with an electronic system. Your job will also be done a lot faster, and with fewer chances for error.

The proofing process changes significantly with electronic systems. With hand stripping, the separator generally creates the color separations and then provides *show-color proofs* or *random color proofs*, which show only the color images. In these proofs, the images are not stripped into their page positions—they are loose or random, and often uncropped; type is not shown at all. This is done because hand stripping is so labor- and materials-intensive that it is important to approve the color (or correct it, if necessary) before proceeding further.

With electronic stripping, however, your supplier will probably show you composite page proofs from the start. Because electronic systems also scan the

type when they scan the images, these proofs will show type elements as well, and everything will be cropped and positioned as it is meant to appear.

Many jobs, however, are still better suited for hand methods than for electronics. If you make many changes during proofing, even minor type changes, you will find that your electronic savings quickly disappear, since going back on the system is very expensive. A simple type change that costs $50 when done manually can easily cost $200 or more when made electronically. Therefore, many buyers whose projects include black type but no colored type prefer that the type not be incorporated into the final black film. Instead, the type is shot on a separate film, so that type changes can be made simply with a new line shot right up until press time.

Also, you must be sure of image rotation if you are using an electronic system. It is relatively easy to turn an image a little to the right or to the left when stripping by hand, but electronically this is cumbersome and therefore costly. On the whole, electronic systems offer some significant advantages, but you must be more organized and keep control of last-minute changes to get the full benefits— otherwise, you will see your bill increase rapidly.

If you have *pickup film* (film from prior jobs) that you need to incorporate into your new piece, this job must be done by hand. Electronic systems must use digital data or convert materials into digital format— they cannot incorporate your pickup data. Magazines, therefore, which use ad films in addition to editorial pages, are not well suited to electronic stripping.

If, on the other hand, you expect to use your electronically stripped pictures again in other four-color projects, an electronic system offers another advantage: Within certain sizing parameters, images can be electronically picked up and reused without the need for rescanning. This means that the color corrections done on your initial printed piece will be reflected in subsequent uses of the image, saving time and money and ensuring continuity.

TRADE CUSTOMS

Over the course of many years, a series of trade customs has developed in the color prepress industry (Fig. 4-4). These practices, which have been tested and upheld in court, refer to very common occurrences in the business. Make sure to read and understand them before beginning any four-color project.

Electronic film assembly may save considerable time and money on complex jobs involving many images and tints. (Courtesy of Scitex America Corp., Bedford, MA)

TRADE CUSTOMS

1. Orders and Schedules. The prepress company shall not incur any liability or penalty for delays due to labor disputes, fires, accidents, wars, floods, or other causes beyond the control of the prepress company.

2. Estimates. An estimate is an offer to perform work based upon information and specifications supplied by the client. Estimates not accepted within thirty (30) are subject to review. Estimates may be revised if the information and specifications for the job change.

3. Cancellation/Delay/Work in Process. If the client cancels an order or withdraws materials while the work is in process prior to completion of the end product, the prepress company assumes no responsibility for the completion of the work and is entitled to compensation for all work completed at the time of cancellation or withdrawal. If work on an order is delayed by the client, a charge may be made by the prepress company to compensate for additional costs caused by the delay.

4. Alterations/Responsibility. No alterations to original materials supplied will be made unless specifically ordered and marked on a layout or proof. The prepress company is not responsible for the quality or accuracy of the original material supplied by the client or client's agency. Neither is the prepress company liable for any fixed stipulated amount as "liquidated damages" should damage or loss occur to any original material furnished by the client. Prepress companies should carry adequate insurance to cover films, electronically created imagery and other materials.

5. Examination Responsibility. It is the responsibility of the client or his agent to examine proofs, blueprints, negatives and positives, or other materials to see that specifications have been met. No claims will be honored by the prepress company unless made within three (3) working days of the client's receipt of the end product. In cases of disputes regarding an end product, the sole responsibility of the prepress company is to correct or replace such end product promptly.

6. Ownership. Each end product produced by the prepress company is the property of the client who ordered the product. All intermediate materials, including electronic data, drawings, artwork, film negatives and positives, separations, engravings, pattern plates, and molds originated by the prepress company and used in the production of end products are the property of the prepress company unless otherwise specifically agreed to in writing.

7. Storage. The prepress company shall retain intermediate materials until the related end product has been accepted by the client. If requested by the client, intermediate materials shall be stored for an additional period of up to one year, for which a charge can be made. Reasonable care shall be taken by the prepress company to provide an appropriate storage environment. Integrity of stored electronic data cannot be guaranteed due to technological limitations of media and devices available.

8. Indemnification. The client shall indemnify and hold harmless the prepress company from any and all cost, expense and damages on account of any and all manner of claims, demands, actions, and proceedings that may be instituted against the prepress company on grounds alleging the job violates any copyright or proprietary right of any person, or that it contains any matter that is libelous or scandalous, or invades any person's right to privacy or other personal rights. At the client's expense, the client shall agree to defend promptly and continue the defenses of any such claim, demand, action or proceeding that may be brought against the prepress company provided that the prepress company shall promptly notify the client with respect thereto and provided further that the prepress company shall give the client such reasonable time as the exigencies of the situation may permit in which to undertake and continue the defense thereof.

4-4. These are the trade customs in the color separation industry. They have been upheld by the courts to protect the rights of separators and their clients.

A few specific comments on these trade customs:

- *Estimates:* All color prepress houses review art boards and or discs when they are submitted and base their quotes on these materials. They reserve the right to requote the job once received. If your job has changed at all since you first received a quote, expect to get a new price.

- *Responsibility:* It is the color separator's responsibility to fix, repair, or indemnify only their own films. Even if the separator makes a mistake, they are only responsible for fixing their mistake, not for any problems or effects *caused* by the mistake. For this reason, make sure you carefully review all proofs and make all necessary corrections. Also, it is a good idea to ask your printer to review all film and proofs and, if the printer feels there are any film problems, to make an additional proof before running your job.

- *Ownership:* He who orders the film owns the film. This means that if your printer orders film for you from a color house, the printer owns the film, not you. If you want to reuse or pick up the film at a later date, you must pay the printer to get it for you. For this reason, either purchase film yourself or have a written agreement with your printer that you own the film once the job is paid for.

- *Storage:* Make sure you discuss storage with your color separator. Specifically, find out how long they will give you free storage of your project materials. If you feel you need a longer period of time because you will need to reuse the materials farther in the future, either discuss this with the separator up front or arrange storage yourself after the free storage period runs out. If the separator is storing magnetic tapes for you, you may want to pay them for extra storage time. These tapes are easily damaged, and the data can be destroyed. Unless you have very good facilities for tape storage, pay the separator to do it for you.

HOW TO WORK BEST WITH YOUR COLOR SEPARATOR

We have discussed how to select the right separator. Once you have made your selection, though, just what do you do?

First, make sure you get the names and telephone numbers of key people in the plant. This includes your customer service representative (who will become your main contact), plant manager, and electronic prepress manager. If possible, speak to your CSR early on and get a good idea about how he or she likes to operate. For example, will you get a telephone call about your incoming job in the morning or in the afternoon? During what hours is your CSR normally in the plant? Does he or she work weekends, or can you at least reach someone else during a weekend emergency? Also, provide your CSR with your home telephone number, so that you can be notified in the event of major changes or problems after regular hours.

Then start to organize your job. Using a project order sheet (Fig. 4–5), see that you have all the information that the separator will need to begin your work as soon as the job gets to the plant. Valuable time is often lost while the CSR and client scramble to get information that should have been included when the job arrived at the plant. For a major project, it becomes even more important to provide clear instructions about what needs to be done. Make sure that you account for every format change, every folio change, and every special design feature of the job.

It is a good idea to treat each page or two-page spread as a separate entity. This means that everything relating to a certain page needs to be in one place. To do this, prepare an instructional tissue overlay on your mechanical, indicating the intended treatment of each element. Next, key all of your art to an alphanumeric numbering system based on page number, working left to right, top to bottom using letters to designate pictures. Thus, the first four-color image on the upper-left side of page 10 will be 10A, the next 10B, and so on. Write these numbers on the corresponding position stats on the mechanical. Carefully double-check each original again for flaws and enclose any color references (swatches, for instance, which should also carry the same number), as the art to which it relates. Anytime you are enclosing something for a color match only, make sure you designate "Color sample only [figure number]—do not scan." This eliminates the

COLOR PRE-PRESS WORK ORDER

To: Spectrum

From: (Name) _____ Today's date: _____

(Company) _____ Desired delivery date: _____

(Phone) _____ / (FAX) _____

(PURCHASE ORDER #) _____

Thank you for choosing Spectrum. Please take a moment to fill out the ORDER FORM below so we can expedite your job into production.

ENCLOSED: _____ transparencies

_____ reflective art

_____ artboards

_____ other (specify _____)

LINESCREEN: ☐ 85 ☐ 100 ☐ 110 ☐ 120 ☐ 133 ☐ 150 ☐ 175 ☐ 200

SIZING: ☐ % given ☐ stat enclosed

CROPPING ☐ full frame ☐ crop using _____

PROOF TYPE: ☐ NAPS ☐ Matchprint II ☐ Velox ☐ Blueline

PRESS TYPE: ☐ Web ☐ Sheetfed

PAPER STOCK: ☐ Coated ☐ Uncoated ☐ Newsprint

FINAL FILM: ☐ RRED negs ☐ RREup negs ☐ RRED positives ☐ RREup positives

Will Spectrum do the stripping for you on this job? ☐ YES ☐ NO

NUMBER OF PAGES: _____

TRIM SIZE: _____ **BLEED AMOUNT:** _____

FINAL FILM: ☐ Single pages ☐ Reader spreads ☐ Printer spreads

COMPOSITE FILM ORIENTATION:

☐ RRED negs ☐ RREup negs ☐ RRED positives ☐ RREup positives

of COLORS: _____ **DUPLICATE FILMS:** ☐ YES ☐ NO

Was this job estimated by your Spectrum sales representative? ☐ YES ☐ NO

Estimate amount $_____.

ON COMPLETION SHIP TO: **VIA:**

_____ ☐ FED EX

_____ ☐ UPS NXT

_____ ☐ UPS 2ND

_____ ☐ OTHER _____

SPECTRUM ● 6275 Joyce Drive, Golden, CO 80403 ● 1-800-426-5677

FAX — 303-425-0655

4-5. A project order sheet, such as this one, breaks down all the essential information the separator needs to know about the job. (Courtesy of Spectrum, Inc., Golden, CO)

possibility that someone might mistakenly scan your color reference rather than your original art. All art and color references for a given page should be placed in a large envelope marked with the page number on which they will appear. Then tape the envelope to the back of the mechanical for that page.

All version changes (black type changes for separate mailings) relating to a given art board should be on overlays with type pasted down in position and the overlay identified by "Page 10, version A, B, C," and so on. If necessary, attach a separate tissue to explain the color break on each overlay, or attach a separate overall instruction indicating "All type on overlays prints 100% black," or whatever. Make a note on your master spec sheet of all versions.

If there are pickups from a prior job, make sure you indicate on each position stat where the pickups come from. You can do this by writing "Pick up fall '88 catalog, fig. 10A" (or whatever image and/or page numbers apply). If possible, get this pickup data to the separator before the major production on your project begins (see Chapter 8 for further details regarding this).

Keep a detailed inventory or log of everything you are sending to the separator. Make sure you keep a copy of the inventory sheet, spec sheet, and major project sheet until your job is completed. Then file these materials with your final invoice, so that you have a complete record of your job.

When you send your materials to the color separator, call your CSR so the separator will know it has been sent. Tell the CSR the name of the air-freight carrier and the airbill number. Make sure you package your materials carefully. Use cardboard between pages, if possible. Use a sturdy cardboard box and cushion any unused space with packaging materials, such as bubble wrap. It is also a good idea to have plastic wrap over the entire package, so that nothing will be damaged if anything spills on it. You may also want to investigate the possibility of purchasing extra insurance.

Make a photocopy of your entire mechanical. It is much easier to talk about your job and resolve any problems easily if you have copies of everything you send.

When your job is received, it will be sent to estimating for review. If the job matches up to your original specs, the price should be the same as originally quoted. Usually, however, there will have been changes since the original specs were given, and

Always allow plenty of time to proof your job carefully under the correct lighting conditions. (Courtesy of 3M Printing and Publishing Systems Division)

All original materials need to be flexible to wrap around the scanner's rotary drums, although newer flatbed scanners do not have this limitation. (Courtesy of Spectrum, Inc., Golden, CO)

therefore you can expect a change in the price of the job once it is actually received.

A schedule will be established and sent to you. Make note of all proofing dates and be sure your calendar is free on those days so that you respond quickly to the proofs. Make sure there is enough realistic padding in the schedule to account for the inevitable job delays.

As you receive proofs, review them and return them promptly (see Chapter 10 for detailed instructions on examining proofs). If you make changes during the course of the project (and almost everyone does), you should get a detailed list of the additional charges. File these with the original materials on your job so that you can identify all changes when you get your invoice. You should plan

for alterations to add another 10 to 20 percent to your total bill.

Remember too that considerable alterations take time to be made. Do not expect the job to stay on the same schedule when you have asked the separator to do significant additional work, especially if the schedule did not have a good deal of padding. To better understand how a color prepress shop operates, let's follow a job through the plant:

SCANNING

The first production step is the scanner department. Here skilled technicians will mount each element on a cylindrical drum and scan it for highest fidelity to color. Make sure you have included written instructions about any changes you want made to the

After the image has been scanned, the operator will examine the films on a light box with a high-powered magnifier. (Courtesy of 3M Printing and Publishing Systems Division)

original color. Review these changes with your CSR so that your scans can be the best possible on first proof. Scanning is not an exact science, so your work may be rescanned several times before the operator feels the right color balance and the best possible rendition of the shot have been achieved.

All materials to be scanned must be flexible in order to be mounted on the scanner's cylinder, so the scanner operator will remove 35mm transparencies from their plastic or cardboard mounts and remove the film. You will find the slide remounted when it is returned to you. Also, original art boards may have to be peeled in order to be flexible enough to wrap around the drum. This will be discussed with you beforehand by your CSR. There is always a possibility that the board can be damaged in peeling, which is why color transparencies of the art are preferable to the original artwork itself.

QUALITY CONTROL

After scanning, there will be some kind of quality review process. If your job is a conventional hand-strip project, then hard copy proofs will be made of each image and these proofs will be reviewed by the quality control department. If corrections are needed they may elect to rescan the image, or recontact or dot etch. If there are extensive corrections needed, this can delay your job. Your CSR should tell you when this happens so that you can readjust your final schedule with the printer.

If your job will be handled electronically, quality control will probably be handled electronically as well. Your images will be viewed on soft-proofing monitors and corrections will be made electronically. It is difficult to completely judge images electronically, so there is always the chance that further color corrections will be needed once the actual films and proofs are made.

FILM ASSEMBLY

Whether your job is being handled conventionally or electronically, all your art boards will be shot and the various elements on your page put together. There are many chances for errors here, so be sure that your instructions are clear and thorough. In your initial job-entry process, you should tell your CSR everything about your project, to eliminate problems at this stage.

PROOFING

Eventually your job will need a hard-copy composite proof for final evaluation. The proofing process takes time and often the proofs themselves need to be remade because of technical flaws.

When the proofs are completed, they will be sent to quality control for evaluation. Again, changes may be made and corrections take time. You may be sent a preliminary proof to evaluate so that the technicians have guidelines about how you want them to proceed. Always return proofs promptly.

QUALITY ASSURANCE

Once everyone is satisfied that the job is correct, it is sent to the quality assurance department for final touch-up. Here each sheet of film is evaluated and any tiny flaws and dirt are removed. Great care is taken to be sure that the film is immaculate. Each layer of film is wrapped in tissue paper and placed in its own envelope. When you receive these materials, keep the film safely wrapped and examine only the proof.

CLIENT EVALUATION

Once you receive your materials, make sure to check them promptly. Double-check to see that all materials have been returned to you, and take an actual inventory to see that you have every transparency, print, and art board. Naturally, make sure that all materials are returned in good condition. If you have any concerns, make sure you contact your CSR immediately—it will be far easier to get any problems corrected at this point than if you wait. Explain the problem and seek a resolution. Disputes should be handled promptly and efficiently. Refer to the trade customs discussed earlier in this chapter to understand exactly what your rights are when problems occur.

After your job is printed, make sure you send a copy of the printed piece to your salesperson at the separator. Ask for suggestions on how the job could even be done better the next time. This type of feedback will help you develop your skills and result in better four-color projects.

✔ **CHECKING YOUR FINISHED JOB**

❏ **Check your inventory and see that all original materials have been returned in good condition.**

❏ **Check films—make sure you have one piece of film for each color.**

❏ **Check bleed and trim sizes for accuracy.**

❏ **Check register.**

❏ **Check tint combinations.**

❏ **Check type for legibility, and breaks.**

❏ **Check color subjects for cropping and color rendition.**

❏ **Check masks and outlines.**

5 TRANSPARENCIES FOR REPRODUCTION

In spite of all the highly complex techniques and sophisticated equipment we have discussed, the greatest determinant of the success of color reproduction is the quality of the input materials used on the project. The best way to save money in color separating and printing is to spend your funds up front to get the best input copy you can.

This is illustrated by the $5–$50–$500 principle. Basically, for every five dollars you spend on input copy (hiring a better photographer, shooting extra images, investing in better lighting, etc.), attempting to achieve the same effects at the film or color-separation stage will cost you $50. And if you wait until the job is on press, obtaining these same

The human eye is capable of seeing a wide tonal range. Color film records a smaller portions of this range, and printing inks are capable of reproducing an even smaller portion. (Courtesy of Du Pont Printing and Publishing)

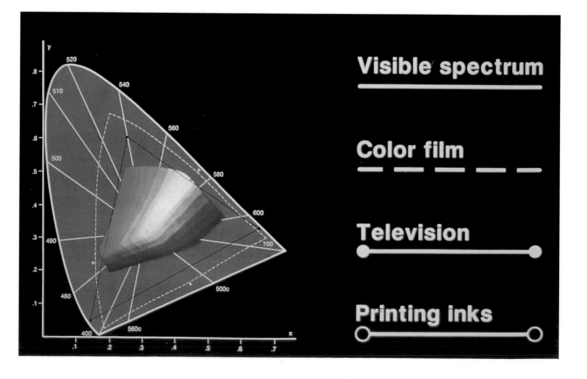

This shot lacks shadow detail. To print well, the separator needs to "open up" the shadows. (Photo courtesy of Gary C. Baker)

further you get from the original image that you are trying to reproduce, the poorer your rendition will be.

The human eye is capable of seeing a wide tonal range. Cameras, however, have a shortened range, and printing inks are even more limited. Color buyers often recognize the compromise of photography but then fail to accept that what they see in a transparency cannot necessarily be reproduced by printing inks.

In fact, the most common instruction given to a color separator is to "match transparency," yet this can rarely be done. Since transparencies have far more information and depth than can ever be captured by printing inks, the color separator is forced to selectively reproduce certain portions of the subject at the expense of other areas. Transparencies, however, because they have superior density and brightness ranges than color prints, offer the separator the best chance of a close match. Also, transparencies are first-generation products and have dye characteristics that are compatible with the dyes in printing-ink pigments. All of these factors make the best type of input material.

Transparencies come in many sizes, from the 35mm to the 2¼-inch square to the four-by-five-inch, the eight-by-ten-inch, or even larger. Recently there has been a definite shift toward small-format photography (35mm or 2¼-inch square), for three primary reasons: First, 35mm film is probably the most advanced film available due to its widespread use by the amateur and professional markets; for the same reasons, the 35mm camera has advanced far beyond its original snapshot capabilities; finally, the advent of laser color scanners has made large blowups easy to accomplish, making large-format photography a matter of choice, not necessity.

Still most color separators would prefer to receive a four-by-five-inch or larger format, because it allows the buyer a better chance to review the materials when they are presented, making any flaws and problems more readily evident. Also, the use of a large-format transparency usually means that someone has taken the time and spent the money to hire a professional photographer, generally resulting in a superior input product.

improvements will cost $500. Thus, you can spend less money and get better results when planning your job efficiently from the start and providing your separator with first-rate input materials at the outset.

Input materials for four-color reproduction can be either *transparent* or *reflective*. Transparencies or slides are the most widely selected materials and are the best choice. Sometimes, however, you will want to use color prints or perhaps original artwork for your separations, so we will discuss these as well.

A standard rule in four-color reproduction is to select first-generation input materials. This means you should select either an original transparency or original artwork rather than a print or duplicate transparency, which are second-generation. The

SELECTING A GOOD REPRODUCTION PHOTOGRAPHER

When selecting a photographer, make sure you select someone skilled in producing photography *for reproduction*. The beautiful transparencies a photographer submits with his or her portfolio may not necessarily reproduce well. It is therefore a good idea to have a photographer show you both transparencies and final printed results. Remember also to consider the paper that you will print on—if you are printing on a low-quality paper, have the photographer bring you samples of his or her work on similar stock.

Hiring a professional photographer is the best way to get something that will reproduce well for you. Many times, however, this is not possible due to budget constraints.

OTHER PHOTOGRAPHIC OPTIONS

The best compromise when you cannot afford to hire a photographer is to select transparencies from a good stock photo house. These are standard shots of various subjects, all taken by professional photographers, and can often work well. One disadvantage is that the photo you choose may have been used elsewhere already, and it might be used by someone else in the future—the stock house will provide it to anyone willing to pay for its use. The cost, however, is less than a typical fee from a professional photographer.

Make sure that you receive original transparencies from the stock photo company—duplicate transparencies will be another generation removed and will not reproduce well. You can tell if you have received an original or a dupe by holding the transparency and carefully examining both sides. Every transparency has both a *base* side, which is shiny, and an *emulsion* side, which looks sticky or tacky. On an original transparency, the image will read correctly when the emulsion side is down, whereas a duplicate transparency will read correctly when the base side is down.

If stock photos do not meet your needs, and if hiring a professional photographer is beyond your budget, you might be forced to take the shots yourself

or have a staff member act as your photographer. This is often the case with trade publications, which have the reporters responsible for a given story also take the photos while getting the editorial information. This will usually result in inferior photography and a lesser-quality product.

An even poorer method is to have readers submit photography to accompany a story. Trade publications again are often faced with using photography from someone who is an expert in a particular field but has questionable photographic ability.

TIPS FOR BETTER PHOTOGRAPHS

When faced with these lesser options, it is important to avoid at least the most preventable problems and mistakes, so that your images will be as good as your limited circumstances allow. Take note of the following photo tips, and pass them along to any nonprofessionals who will be taking photographs for reproduction on your projects.

- Submit transparencies, or slides, rather than color prints.
- If using 35mm transparencies, shoot them on Kodachrome film, or a slow-speed Fujichrome or Ektachrome.
- Use the proper film for the lighting situation (i.e., daylight film outdoors and tungsten film indoors).
- Use a tripod whenever possible.
- Make sure you use a flash when shooting outdoors as well as indoors. This cuts down the contrast and will give a full-range shot.
- Do not submit Polaroids for reproduction—the results are inevitably poor.
- If possible, try to shoot the same image several times. Shoot once at the correct exposure, then half an f-stop overexposed, half an f-stop underexposed, a full f-stop over, and a full f-stop under. Submit all versions of a given image, if possible.
- Use a professional film lab to develop your film.
- If forced to submit prints, use a matte- or glossy-finish proof; avoid silk- or canvas-finish prints.
- If submitting a color print, have the print made oversized and provide the negative as well as the print.

A low-speed film, such as Kodachrome 25, will have less grain and will reproduce better than a high-speed film, such as Ektachrome 200. (Courtesy of Eastman Kodak Company)

KODACHROME 25

EKTACHROME 64

KODACHROME 40

EKTACHROME 160

KODACHROME 64

EKTACHROME 200

EKTACHROME 50

EKTACHROME 400

• If in doubt, shoot many images and many versions of the same subject. Often a different angle or exposure will give you the desired effect.

Most nonprofessionals will welcome this help— they want to see their work look good.

COLOR FILMS: WHAT WORKS

When choosing color film for taking photographs for reproduction, you must strike a compromise between *speed* and *grain*.

A film's speed refers to its ability to capture light. You can determine a film's speed by referring to its ASA or ISO number, which will be printed on the film package—the higher the number, the greater the film's speed. High-speed films can produce images in low-light environments, while low-speed films only function well in brightly lit environments.

High-speed films, however, have the serious drawback of grain. Grain—silver particles that remain in the film after it has been processed—is the enemy of good color reproduction. It appears as little specs on the image. It is therefore best to shoot your photographs for color reproduction on low-speed film. But low-speed films will not work well in diminished-lighting situations, which necessitate high-

speed films. Obviously, you will have to take your photographs in areas that are as well-lit as possible and use the lowest-speed film appropriate for the setting, thereby striking a balance between film versatility and grain.

Assuming you have a well-lit environment that allows low-speed, low-grain film, one of the best films available for color reproduction is Kodachrome 25 film by Kodak. All Kodachrome films are low-grain films. They come in two varieties: 25 ASA and 64 ASA. Unfortunately, they are only available in 35mm format, so that for larger-format transparencies, you must select a Fujichrome, Agfachrome, or Ektachrome film.

Kodachrome films must be developed by a Kodak lab. This means that although you may bring your Kodachrome film to your local professional film lab, the lab will send it to Kodak for processing, which usually means the film will not be returned to you for two days. In very tight deadline situations, therefore, this can be a handicap. (By the way, you will note that all transparency [positive] films end with the suffix *chrome*, and all print [negative] films end with the suffix *color*. This is an easy way to know that you have selected the right film for the job.)

Here are three versions of the same Christmas shot. The one at top left is underexposed; the one at top right is overexposed; the bottom image shows the correct exposure. (Photographs © Jerry Gabrielse, Photographer)

Exposure is a primary consideration in providing the best quality transparencies for reproduction. What looks best on the light table may not be the best choice for reproduction purposes. This is because the shortened tonal range of ink on paper may not be able to capture many of the subtle variations in the original transparency. The range of offset lithography is generally about four f-stops on the camera. All data within that narrow range can be reproduced; all that fall outside of these very definite limits will be lost.

There are two schools of thought regarding this problem. One maintains that the buyer and the photographer must be aware of the tonal losses and accept them, but shoot for a full-range transparency. This transparency will probably have a density range beyond the capabilities of the offset press, necessitating compression in order to successfully reproduce that transparency.

An opposing view, however, is that you should shoot strictly for the shortened offset lithography range to avoid disappointment. This technique is known as *four-stop photography*, referring to the range of the offset press.

The details for implementing four-step or measured photography are quite complicated. The image must be carefully controlled throughout the photographic

This shot is well lit. There is detail across all points in the tonal range, giving the color separator the best chance of success. (Photograph © Jerry Gabrielse, Photographer)

process, from the shoot through the final developing. It is usually necessary to work carefully with both the color separator and the film lab to see that they institute the careful quality controls needed to implement the technique. Also, the photographer will probably need to invest in additional equipment. For instance, a Sinar probe is necessary, and costs about $1,500.

Because of these factors, four-step photography has not gained wide acceptance. The most common compromise is bracketing.

BRACKETING

Bracketing—shooting an image at several different exposures and then selecting the best rendition—is an important way to ensure good color reproduction. You should insist that your photographer bracket all shots. Ideally, you should shoot each image five times: First at the correct exposure, then half an *f*-stop over, half on *f*-stop under, a full *f*-stop over, and finally a full *f*-stop under. Once you have all five images, examine them carefully on your 5000K light box. Then select the one with the most detail.

When examining the bracketed shots on your light box, use several inches of illuminating surface surrounding the chromes. The transparencies should not be in a black mat, since this gives a distorted perception. Also, do not examine transparencies through a slide projector, since this does not give accurate data.

Now select the image with best detail throughout the tonal range, from highlight through shadow. If in doubt, select the one you think is the best, indicate your selection, but then send all five to the color separator, who will be the best judge concerning which image will reproduce the best.

FILL-IN FLASH

Fill-in flash—the use of additional flash lighting to establish uniform subject illumination—is important for good color reproduction because high-contrast photos with large tonal differences between highlight and shadow will not give a pleasing shot. To prevent harsh breaks in skin tones and other problems, make sure there is plenty of light on people, even outdoors. Usually a supplementary flash will work, although more extensive supplementary lighting (white boards, foil reflectors, or umbrellas) will be even better. Modern computerized strobes are easy to use and provide full lighting for better four-color results. Furthermore, there needs to be local contrast for modeling the subject. A flat subject, such as one with white-on-white detail, can cause reproduction nightmares. Again, make sure that your lighting is directed at producing the maximum amount of detail possible.

Be especially aware of the highlight detail in your subject. The human eye is most sensitive in this area, and therefore the scanner operator will always try

✔ **DIFFICULT SUBJECTS TO REPRODUCE**

❏ **Subjects with built-in moirés, such as checks or plaids.**

❏ **White-on white or black-on-black detail.**

❏ **Dropouts of hair, bicycle-wheel spokes, or other intricate parts.**

❏ **Grainy subjects requiring enlargements of over 1,000 percent.**

❏ **Subjects requiring outlines with no clear definition between subject and background, such as a black object on black background.**

❏ **Metallic colors, such as jewelry, gold lamé fabric, and so on.**

❏ **Fluorescent colors.**

❏ **Subjects with many subtle pastels.**

❏ **Subjects with flat lighting or a lack of internal contrast.**

❏ **Subjects with excessive contrast in key areas.**

The white-on-white detail in this shot creates a challenge for the color separator. (Photo courtesy of Gary C. Baker)

Blue sky, green leaves, and the colors of the American flag are "key" colors. People have idealized mental pictures of these colors, so it is important that they be reproduced exactly as we expect them to appear. (Photograph © Jerry Gabrielse, Photographer)

The image at left has an overall red cast. When it is separated for reproduction, the cast should be removed so the image will print well. The final proof should look like the version on the right. (Photographs © Jerry Gabrielse, Photographer)

to preserve as much highlight detail as possible, but the initial detail must be there to work with. Transparencies with excellent highlight detail also tend to have excellent color saturation.

Photographs should also have the correct color balance. We all have visions of how certain things ought to look—flesh tones, the American flag, blue skies, green grass all conjure up very specific colors in our minds. These key colors should be accurate on the chrome when they are sent to the color separator.

OUTDOOR PHOTOGRAPHY PROBLEMS

Outdoor shots often have a blue color cast over the entire image. Modern scanning equipment is capable of removing this cast, but the overall color often suffers in the process. For this reason, when shooting outdoors, try using a 85B pale-blue filter, which will filter out the blue band of light and make the image better suited for color reproduction.

An even more prevalent problem is the overall

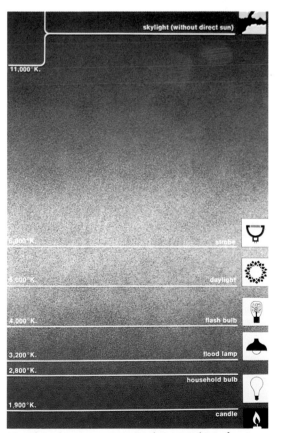

Note the color temperatures (in degrees Kelvin) of various light sources. Remember that ideal standardized viewing conditions call for 5000K lighting. (Courtesy of Spectrum, Inc., Golden, CO)

green color cast created under fluorescent lighting conditions, another outgrowth of the camera's inefficiency when compared to the human eye. To compensate for this, try using a 5 magenta filter, which will absorb green, and a 20 blue filter, which can absorb the red and green bands. This should give you a neutral shot that will produce more accurately.

If possible, shoot outdoor shots on an overcast day. The overcast conditions give better total contrast, but try to exclude the overcast sky itself from your shot, since it will reproduce as a flat gray.

In addition to the lighting conditions, you must consider the weather and time of day. Before sunrise, for example, the world is black and white, devoid of color. To reproduce in this very limited light, you need a long exposure, which in turn necessitates a tripod. Moreover, most color films have been balanced or formulated to work best between 10:00 A.M. and 2:00 P.M.

Early in the morning, under bright sunlight, images can appear harsh. It is easy to achieve a high level of pictorial detail at 10:00 A.M., but there can also be a sharp delineation between highlight and shadow, so there is a need for fill-in flash under these circumstances. Late in the day, a warm, romantic light predominates. There is usually a haze later in the day, again, necessitating long exposures and a tripod.

On a foggy day, all colors are muted and there is little delineation, making all subjects very difficult to reproduce. Rain has a similar tendency to dim everything—details are lost, color contrasts are diminished—again resulting in poor reproduction. Details also disappear during a snow storm—colors are subdued and everything can look very monochromatic and dull. Strong-colored objects can offset this a bit, providing some color interest, and shooting snow scenes late in the day can provide some textures, adding detail to the shot.

CORRECTING PHOTOGRAPHY

When an image is not what you want it to be, you often resort to some sort of retouching to make it right. Retouching today is done in three ways: airbrushing a print, retouching a transparency, or electronically retouching separation films.

✔ EVALUATING FASHION SHOTS

❏ Whites should remain white without losing necessary fabric detail; the same holds true for blacks.

❏ Check garment colors against any swatches that are supplied.

❏ Check flesh tones for good overall color.

❏ Be alert to flaws on garments, wrinkles, spots, poor stitching, or pins.

❏ Check for undergarment creep, such as with bra straps.

❏ If background or auxiliary colors have changed, but other elements look good, do not correct.

❏ Check for skin imperfections, blemishes, five-o'clock shadow, and so on.

✔ EVALUATING OUTDOOR SHOTS

❏ Check clouds for whiteness.

❏ Check grass and trees for proper color rendition and detail.

❏ Check neutrals, such as grays and beiges, for any color shifts.

❏ For snow shots, look for detail in snow; color cast should ideally tend toward blue, but not excessive blue.

❏ Look for overall sharpness across the entire subject.

❏ Check for distracting elements and flaws, such as television antennas, telephone lines, brown spots in grass, and so on.

✔ EVALUATING INTERIOR AND ARCHITECTURAL SHOTS

❏ Check for obvious flaws, such as an untidy desk, garbage cans, and so on.

❏ All lighting should appear natural; specifically, see that multiple light sources do not cause unwanted shadows.

❏ The color temperature of all light sources should be identical (cool light sources are best—strobe or 4800K tungsten lamps).

❏ Check for unwanted reflections of camera, mirrors, and so on.

❏ Keep important details of the shot in a four-to-one lighting ratio.

❏ For window shots, balance interior lighting to exterior lighting to show detail on drapes and curtains.

✔ EVALUATING FOOD SHOTS

❏ Food should look realistic and appetizing.

❏ Check detail areas on linens, silverware, and food.

❏ Check for color casts in china, tableware, and linens.

❏ Watch for white-on-white detail problems with potatoes, whipped cream, and similar items; ideally, any slight color cast should tend toward blue.

❏ Check for unwanted reflections of lights and/or camera on silverware and china.

❏ If the food looks good, disregard changes to the background.

The least expensive but most problematic way to retouch is to airbrush a print. The first problem is that this method implies the use of poor input material—a print. In addition, airbrushing presents two problems: First, airbrushing dyes do not match photographic dyes. Although your eye fills in the visual data and makes the airbrushed area look like its nonairbrushed equivalent, this is not so. If in doubt, you can prove this for yourself by taking a piece of neutral-gray construction paper and cutting it in half. Then cut a hole out of each half, perhaps an inch in diameter. Take an image that has been airbrushed and place one hole over the airbrushed area and the other one over its nonairbrushed "match." By comparing the two sides in this controlled environment, you will see that the two colors do not correspond, which is why most color separators charge an additional premium when customers present them with airbrushed prints.

Another airbrush problem is that any differences in texture caused by the airbrush will be perceived as differences in color by the color scanner. To check an airbrushing for this problem, examine the airbrushed area using a Kodak Wratten #58 green gelatin filter,

This excellent shot was done with no direct light or strobe. It was shot through diffusion panels. A similar technique could be used for photographing jewelry. (Photo courtesy of Gary C. Baker)

The client requested that the eyes be changed from a greenish blue to a true blue. The electronic retoucher altered the pixels and made this change electronically, rather than manually. (Courtesy of Scitex America Corp., Bedford, MA)

which will help you see any imperfections. If there are problems, return the airbrushing to the retoucher, since there will be color problems later in the printing processing if this defect is not corrected.

If you select transparency retouching, you will not have as many problems, but you will spend at least twice as much money. The retoucher will usually make a duplicate transparency and retouch the dupe so that your original will not be damaged if any mistakes are made. Assuming a Kodak film duplicate is employed, make sure your retoucher uses only Kodak dyes, since these will correspond best to the dye sets in the actual transparency.

Today, more and more retouching is done electronically. There are advantages and disadvantages to this technique. While traditional retouching is an art that requires the skill and finesse of an artist's hand, electronic retouchers are relative novices, often lacking this delicate touch. It is wise, therefore, to find out how long your color separator's electronic retouchers have been doing this type of work, or if they were artists or traditional retouchers before learning the electronic way.

As you might expect, electronic retouching can be extremely expensive—usually $500 to $600 per hour. At these high rates, your charges can add up very quickly. Newer desktop retouching systems cost far less but have serious limitations, the most problematic of which is their inherently low resolution—when the retouched images are transported into high resolution for printing, the retouching work does not translate. (See Chapter 9 for more desktop information.)

High-resolution electronic retouching, however, does offer superior image quality, and has the advantage of taking place on the separator's premises, thereby eliminating the need to use yet another vendor in the course of your project. It is also fairly fast, which can mean the difference between meeting or blowing a deadline. Also, if your retouched subject will be used for many purposes and at many different sizes in subsequent jobs, retouching it once electronically will ensure that each future use will be identical to the first.

✔ EVALUATING PEOPLE SHOTS

❑ Hair should be sharp with detail.

❑ Eyes should have clear highlights.

❑ Check lips and teeth for brightness.

❑ Check overall skin tones for pleasing color balance.

❑ If flesh and hair look good, disregard any changes in background color— the flesh and hair tones are more important.

❑ Make sure nature of background does not conflict with subject.

✔ EVALUATING PRODUCT SHOTS

❑ Check colors against any product swatches that are supplied.

❑ Check type clarity on packages.

❑ Check whites and neutrals for color balance.

❑ Do not correct the background and prop colors if the product colors are accurate.

6 COLOR PRINTS, ARTWORK, AND OTHER INPUT MATERIALS

IF YOU SUBMIT A COLOR PRINT

As we discussed in Chapter 5, color prints must be seen as substandard materials for color reproduction. This is because they are a second-generation product, which means that much of the essential picture data are missing. Although many color separators urge their inexperienced clients to use color prints because they are closer to what can be achieved in color reproduction, considerable compromises are necessitated by going this route.

To understand the quality loss inherent in working with prints, consider this: You can safely enlarge a good Kodachrome transparency by up to 2,000 percent, and a good Ektachrome by 1,000 percent, but a color print should never be enlarged more than 150 percent. Ideally, a color print should always be submitted at the correct reproduction size, or even slightly larger than the final reproduction will be. In this case, the color separator can reduce the image, giving a sharper rendition.

You should always use a professional film lab to make your prints. The prints should always be made on white paper with a smooth surface. The print can have either a matte or glossy finish, but canvas- and silk-finish proofs are not acceptable, since the emulsion layer of the film is damaged in the making of these prints.

There are three basic methods for color print making. There is the type-*C* print, the type-*R* print, and the dye-transfer print. A type-*R* print is made directly from color transparencies without using an intermediate negative, and is not acceptable for color reproduction.

The most commonly used print for color reproduction is the type-*C* print. Most people erroneously believe that the designation *C* stands for *color*; actually, it represents the third generation of print-making technology developed by Eastman Kodak. Type-*C* prints are made from intermediate negatives. By working from the negative, a skilled photo technician can make a full-range print that will reproduce well and can even be color corrected.

Dye-transfer prints, the third and most expensive form of print, are not used as extensively today as in the past. They have largely been replaced by electronic retouching, which can more easily accomplish the superior color changes that dye-transfer prints once offered exclusively. Dye-transfer prints are made by actually separating the original transparency into its three dye layers—yellow, magenta, and cyan—by shooting the image on a camera. Once the dye layers have been separated, a skilled technician can work on each of the colors and make subtle or extensive corrections on the films.

Because the prints themselves can cost $500 or more, in addition to the cost of color separations, these prints have fallen out of favor.

EVALUATING COLOR PHOTOGRAPHY

One of your primary tasks will be to evaluate the quality of the photography that you select for color reproduction Remember the $5–$50–$500 principle—you should send the very best product to the color separator, since it will be far too expensive to have the separator restore poor material for you.

To make these determinations, you will need to spend time examining your prints and transparencies. Make sure you use a 5000K light box and a magnifying glass with at least 10 × magnification. Quality magnifying glasses are made by several manufacturers, and come in several shapes and sizes. They cost around $50, a worthwhile investment considering the cost of color printing.

When you want to evaluate color transparencies, go to your light box. First examine the transparencies overall to spot obvious flaws. Did anyone move in the picture, causing a blurred image? Are there scratches or dirt in the transparency? Are there processor lines running through the transparency? If any of these problems are present, this is not a good candidate for

color reproduction, and you should have the work redone.

If this is not possible, the color separator can remedy many of these problems, but there will be considerable additional charges. The easiest problems to correct are the dirt and scratches. This can be remedied by electronic retouching. Processor lines and movement, however, will force the separator to diminish sharpness to avoid reproducing the imperfections, and you probably will not be pleased with the results.

Most transparencies will not have these obvious flaws, so place the transparencies on a light box, take out your glass, and examine tiny detail areas. Check eyelashes, tree branches, type on packages, and similar areas to see that they are crystal clear.

Keep in mind that sharpness is the biggest determinant of color reproduction success. Buyers who make compromises on sharpness are often disappointed by the results. Do not neglect to examine your materials up front with a critical eye in the mistaken belief that the separator can work miracles.

If your transparencies pass the sharpness test, then you should examine them for exposure, an area that modern scanning equipment can manipulate very

A magnifying glass with at least 10× magnification is a must for evaluating photography. (Courtesy of Spectrum, Inc., Golden, CO)

successfully. Scanners have the ability to bend or alter the reproduction curve, meaning that the scanner can affect one portion of the image without changing the remainder. Thus, if an image is over- or underexposed, the scanner can correct the curve and make the image appear normal.

By bracketing your shots (see Chapter 5), you can see the full range of exposures possible from your transparencies and decide which one looks best to you. Remember, since exposure can be corrected on the scanner, your choice should not be based on exposure alone. If you are at all unsure, you may want to send all five shots of the bracket to the separator so that they can select the one with the most sharpness and detail.

If your transparency passes the sharpness and exposure requirements, then you can look at the color. Color is the easiest portion to correct— the separator has infinite control over color once the other factors are in good shape.

Transparencies with a low density range and minimal detail are very difficult to reproduce. (Photo courtesy of Gary C. Baker)

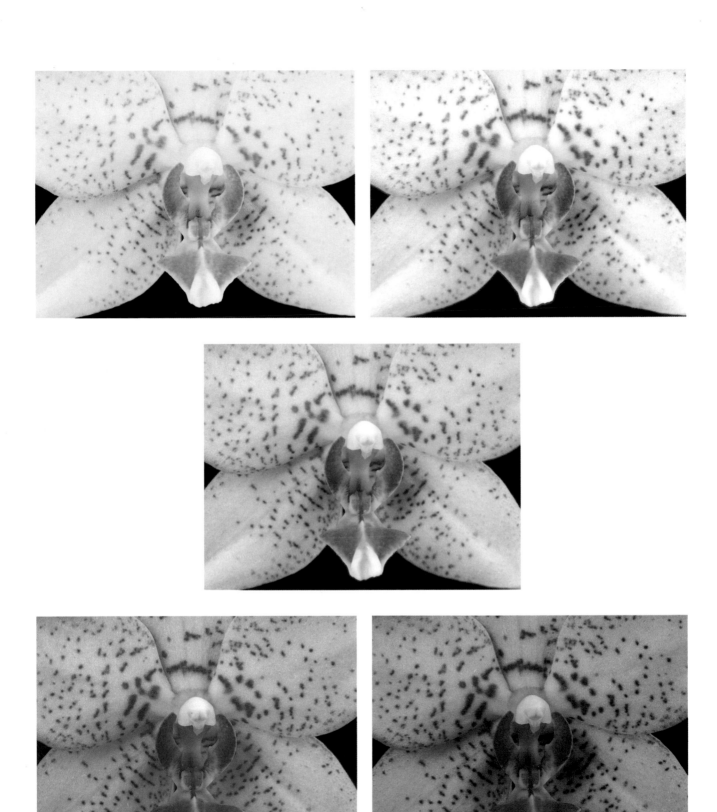

Bracketing your images at five different exposures gives you the best chance for success. In this instance, the center image will reproduce best. If in doubt, send all five brackets to the color separator. (Photographs courtesy of Gary C. Baker)

The outdoor shot on the left has a strong blue cast, while the similar outdoor shot on the right was taken with proper filtration on the camera lens. (Photographs courtesy of Gary C. Baker)

HELPING THE SEPARATOR

The most common instruction given to any color separator is "Match transparency." In fact, the most commonly heard complaint from color buyers is "All that I ever asked them to do was to match the transparency, and they didn't even do *that*." To avoid this disappointment, give clear instructions as to *exactly* what you want done. Usually, for instance, you will not want to match the entire transparency, but rather there are some key elements in the picture that are important to match precisely. Moreover, keep in mind that the inherent limitations of the printing process make a true match impossible.

Most color separators will always aim for good flesh tone reproduction when people are featured in the image. For scenic subjects, they usually will try to make the skies blue and the grass green. If a product is pictured, the essential element will be to accurately reproduce the product itself. Make sure you let the separator know what is important to you and what

you are willing to sacrifice. When it is important that the separator match a particular product, always supply a fabric swatch or a paint chip or a sample of the package as a color reference. Swatch-match reproduction, however, usually will cost more than standard transparency work, because the separator must do far more extensive color correction to match a swatch.

In all instances, a primary rule in color instructions is "Show me, don't tell me." When you want a specific color matched, always try to provide a reference. Use your color-matching book to reference color. You will be far more successful telling a separator that you want a sky to look like PMS 383 than by telling them to "give me a pretty blue sky."

ORIGINAL ART

Original artwork, such as a painting, poses an even greater problem for the color separator. Whereas photographic materials have given dye characteristics

that are somewhat predictable, original artwork can be created from a wide range of media, each one with specific dye characteristics, and the separator must transform this endless variety of dyes into printing negatives that will work on a press with a rigid set of ink pigments. This transition process is far less predictable for original artwork than for photographic materials. For this reason, most separators charge an additional premium when working from original artwork.

Also, original artwork often is inflexible. Scanners have cylindrical drums, which means that the input copy must be flexible to wrap around the cylinder.

If you need to match a particular color, use your ink-matching book to specify it. (PANTONE® is a registered trademark of Pantone, Inc.)

A gray scale, such as this one, should be placed in a nonprinting area of copy transparencies and reproductions of original artwork. (Courtesy of Spectrum, Inc., Golden, CO)

Original artwork, however, is often inflexible or mounted on rigid board, and this poses additional problems. You must be conscious also of the size of your art board. Check with your scanner house—most scanners have a maximum 20-by-24-inch input size, and others are even smaller. Plan your work with this in mind.

There are basically three solutions. Ideally, prepare your artwork on a board that can be easily peeled so that the paperlike top layer can wrap around the drum. The best board to use is a Crescent cold-pressed board or a Crescent scanner board. These boards peel easily, but you run the risk of the board tearing. In fact, the separator will always ask your permission before peeling the board, to eliminate their liability should the board be ruined.

If you have oversized and/or inflexible copy, you might have to resort to using a copy transparency. Copy transparencies are prepared by film labs or can be done by your color separator. You can request either a 4 × 5 or an 8 × 10—a 4 × 5 may work well if you don't need to enlarge the image much, but for a large-size, high-detail separation, you should consider the larger and more costly 8 × 10 transparency.

In any case, the copy transparency will be one generation removed from your original subject, so there will be an inherent loss of detail and perhaps color shifts as well. You may choose, therefore, to send both the copy transparency *and* the original artwork to the separator, so that they can reference back to the original art for color. Expect to pay an additional premium for this color match.

Whenever having a copy transparency made, it is a good idea to place a *photographic gray scale* (available at photo-supply stores for about $10) outside the reproduction area, such as on the frame of a painting. By acting as a set of constant, known values, the gray scale will serve as a mirror to what has happened in the copy transparency process. The separator will have an identical gray scale on hand, and can see if the transparency processor caused a color shift, and if the color is being reproduced accurately.

Another alternative for nonflexible or oversized original artwork is to send the artwork to a vendor

equipped with a process camera rather than to a scanner house—problems of size and flexibility become moot. Cameras, however, do not have the sensing mechanisms of scanners, and therefore achieving a similar level of quality from a process-camera separation will require hours of tedious handwork, which will be very expensive and take additional time to complete.

So which method is best? Despite the cost, the camera method is best when you need separations made for high-quality, limited-edition print work; when time is not a factor; when you need large-sized separations; and when you are concerned about the possibility of damaged artwork.

If, however, you need separations that can be done by peeling an art board, such as illustrations for a magazine or book, the best method is probably a scanner separation from the art itself. Although this does involve peeling the board, the damage risks are minimal, and working from the original material is far better than working through a copy transparency of the art.

In cases where the original material is inflexible or oversized, you must resort to a copy transparency. If color is not overly critical, just submit the transparency; if color must be exact, submit both the transparency and the original art.

There are other things to remember when submitting original artwork: for instance, crayons do not reproduce well; any fluorescent medium is a poor choice for reproduction; Chinese poster white will crack when bending around a scanner drum.

Watercolor is probably the best medium for producing accurate color separations, as long as you are not using fluorescent colors. Markers also reproduce well. Oil paints are worse, because they tend to be applied in varying textures, which the scanner mistakenly sees as variations in color. The same problem holds true for collages, or for any inherently textural medium. For original art of this sort, a copy transparency is best. Remember also to keep your artwork on a smooth board—scanner lighting mechanisms are very sensitive and will actually pick up the grain and texture of your art board, detracting from your reproduction.

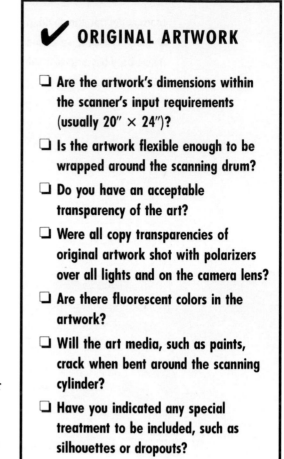

✔ ORIGINAL ARTWORK

❏ Are the artwork's dimensions within the scanner's input requirements (usually 20″ × 24″)?

❏ Is the artwork flexible enough to be wrapped around the scanning drum?

❏ Do you have an acceptable transparency of the art?

❏ Were all copy transparencies of original artwork shot with polarizers over all lights and on the camera lens?

❏ Are there fluorescent colors in the artwork?

❏ Will the art media, such as paints, crack when bent around the scanning cylinder?

❏ Have you indicated any special treatment to be included, such as silhouettes or dropouts?

No one has done a comprehensive study showing exactly which pigments reproduce well and which can never be recognized by the scanner. All scanners have a problem discriminating between the reds and oranges—they tend to see, and therefore reproduce, orange as red, and often show red tending more toward the orange. For a critical project, it may be wise to submit swatches of your media colors, so the color separator can then make test scans for you and show you how these particular pigments will reproduce. While there will be a charge for this service, it can save money, time, and headaches later on (remember the $5–$50–$500 principle).

Another advantage of color scanners for reproducing artwork on a board is that if you specify in advance that you want the background dropped out to white, the scanner can often handle this masking process electronically, saving you money and time while providing a very accurate mask. This mask is created by setting a threshold density and

programming the scanner to drop out to white all tones below the threshold. It is an ideal method, although it sometimes cannot be used if part of the image itself has a density value at or near the threshold level. In this case, a traditional hand-cut mask must be created.

OTHER INPUT MATERIALS

For fabric images, sometimes you can submit actual fabric swatches to the color separator. Depending upon the weave and the thickness of the material, you may be able to have the color separation made directly from the fabric swatch. If the material is too thick, or if the separator feels that there is a possible moiré problem, you will need to shoot a copy transparency and submit that to the color separator.

Finally, if all else fails, you can submit previously printed materials (often referred to as *tearsheet*) to the color separator as input copy. This is the worst material to use, but sometimes circumstances mandate it. When you need to use prescreened copy, do not expect the best results, and be aware that the separator may charge an additional premium. To help make the best of a bad situation, make sure you submit as good an original as possible. Select a clean printed piece, in register, without any damage. Finally, if possible, try to reduce the image from its original size; do not attempt to enlarge from the original printed piece, since it will fall apart as the separator juggles the very difficult task of trying to create new dots without interfering with the dot pattern already present in the printed piece.

Take great care with all your input material, whatever its format. Avoid paper clips, which can damage a transparency or even a piece of artwork—if you have further instructions for the separator, use peel-and-stick notes rather than paper clips. Also, never submit slides in glass mounts—the glass can break and seriously damage the transparency.

The less you handle your materials, the better. Put all transparencies in protective plastic sleeves; spray prints with a thin, protective coat of nonreflective matte fixative. The greatest tragedy is when everything is done correctly and then a transparency, print, or piece of artwork is ruined by a careless error.

SIZING

In today's high-tech color world, it is even more critical than ever that small mistakes in sizing copy are eliminated entirely. Most separators require that jobs be submitted with photostats showing proper image size and position, since a small sizing change or a difference in the rotation of the picture can mean big problems when the job is processed. Commercial stat houses tend to be expensive; your best investment, then, would either be a stat camera or, if you are producing your job on a desktop system, a low-resolution, black-and-white scanner for producing stats.

Each photostat should be pasted down on the mechanical or included on your desktop output in the position where the image will fall on the page. An indication of *FPO*, or *For Position Only* should be written directly across the picture, so that there is no confusion about the stats being camera copy rather than size and position guides. When sending your project to the separator, give instructions that your images be scanned to match the stat sizes, rather than to specific enlargement or reduction percentages. This virtually eliminates mistakes: Anyone can make a sizing error (especially when enlarging a small slide by several hundred or even more than a thousand percent)—you can, and the separator can; when stats are used, however, the image can be held up to the stat as soon as it is scanned. If there is a perfect size match, it's fine; if not, meaning an error was made, it can be rescanned quickly and easily at a very low cost.

If, however, you cannot submit a stat, you will be forced to use one of the two standard sizing methods; I recommend using *both*. Give the separator or printer both an enlargement or reduction percentage *and* an indication of the image dimensions. Many buyers still use a proportion wheel for calculating the focus percentage, but this is just not accurate enough. The more modern and accurate approach is to use a calculator. To determine the percentage of enlargement or reduction, choose to work with either the horizontal or vertical dimension and divide the final desired size by the original size. Thus, if you want a four-inch-long image to appear as 12 inches

wide, divide the desired size of the reproduction (12) by the original size (four), giving you three, which means 300 percent. (Most calculators do not automatically convert decimals to percentages, but it's simple to remember that 1.0 is 100 percent, 0.10 is 10 percent, and 0.01 is 1 percent.) Since inch fractions (4⅝ inches, for instance) are cumbersome to work with on a calculator, you may find it easier to make your measurements using a ruler based on decimal-oriented system, such as a pica or centimeter ruler.

Remember, however, if you are giving the color separator only a percentage for sizing, it is a good idea to also furnish the size of the window that the image will go into, and to indicate whether this size includes a bleed allowance. This allows the CSR at the color separator to perhaps double-check your calculations, which can help identify mistakes at an early stage, before they cause big problems.

ART BOARD PRESENTATION

Preparing four-color art boards, or mechanicals, is relatively easy. Ideally, you should prepare a style sheet or spec sheet for the printer or separator (Fig. 6–1). On this style sheet, indicate the bleed and trim sizes of the page. State where common elements fall ("The folio belongs 1 inch in from the bottom of the page and 1 inch from the edge," for example), and review common tints ("All subheads print 100Y, 100M").

All your type and other line elements, including line-art figures, should be done in black and positioned on your art board in their exact positions. They will be shot directly as camera copy. The board must be clean and every element must be straight. Double-check and make sure that you have exact center marks and that your bleed and trim marks are accurate. Make sure that every screened image is represented by an accompanying stat pasted down on

Spectrum Layout Guide

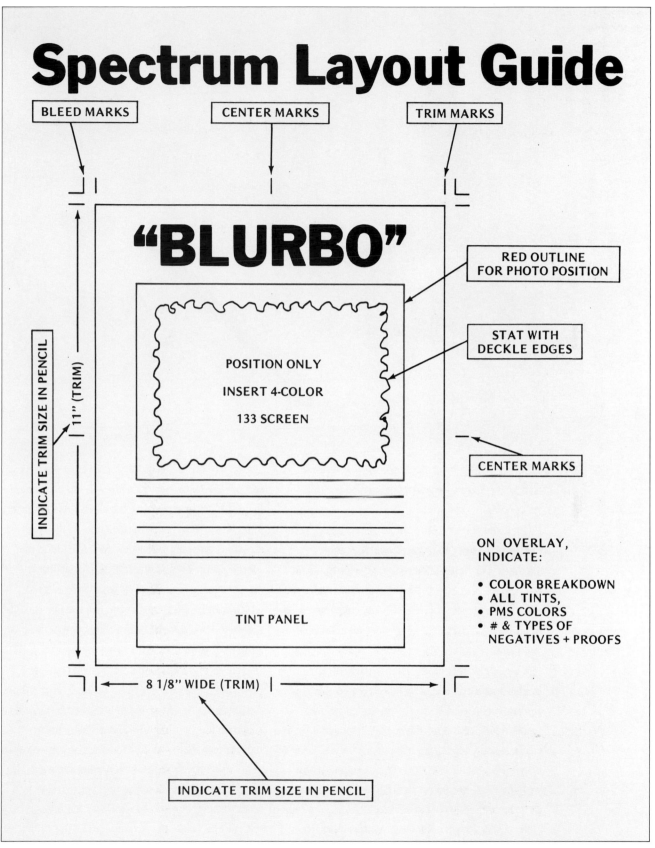

6-1. Be sure to mark bleed, trim, and other requirements on your mechanical. Check with your printer to confirm all specs. (Courtesy of Spectrum, Inc., Golden, CO)

Traditional art board prep materials are gradually being discarded in favor of electronic mechanicals, which incorporate current desktop technology. (Courtesy of Scitex America Corp., Bedford, MA)

the board, with *FPO* or *For Position Only* written on the stat. Make sure your cropping and rotation are correct.

Once you are sure that your art board is perfect, you must start to communicate with the color separator. The best communication device is a tissue placed over each board. The tissue is your chance to show the separator or printer what needs to be done to transform the art board into film, and ultimately into print.

When the printer or separator is assessing a mechanical board, one of the most common areas of confusion concerns *keylines* (also called *holding lines*). A keyline is a ruled box, usually drawn directly on the board, indicating the boundaries of a screened image. The printer uses the keyline, in conjunction with the FPO stat placed within the keyline, to strip an image into its proper position.

Because a designer will often want an image to appear within a box, there can be some confusion as to whether the keyline is meant to print around the image or if it is to be used as a positioning guide only.

One way to avoid this problem is to cut a deckled, or scalloped, edge around the FPO stat; this is commonly understood to mean that the keyline should not print. Another way is to give an instruction on the tissue ("Holding line only—does not print," or, if the rule *should* print, "Image butts rule; rule prints 100% black"). Finally, you can draw your keyline in red, which is an easy way to indicate that the line should not print. I recommend using at least two of these methods together.

Make sure to indicate on the tissue if an image prints full-frame or if it is to be outlined. The outlines or silhouettes or dropouts can be shown by drawing a rough outline on the position stat. Make sure to indicate if there is a drop shadow remaining as well.

After you have indicated everything about the images, it is time to describe the type and tint elements on the page. The ideal way to do this is to use color to communicate color, preferably in the form of a legend in a nonprinting area or on a separate sheet of paper, describing exactly what happens to every piece of type.

For tints meant to simulate a matching-book ink color, make sure you give the appropriate combination. Do not just put a colored swatch on the board with instructions to "match PMS 353"—every stripper will give you a different formula. Instead, specify the exact tint recipe. Use colored pencils or markers to show where you want each color combination to appear.

SPECIAL ART BOARDS

The following tips will help you in special circumstances that you may encounter:

1. When preparing a two-page spread rather than a single page, make sure to indicate if the material will appear in a saddle-stitched or perfect-bound book. Your color separator needs this information because the film preparation must be done differently for each situation. If the spread is for an ad in a perfect-bound magazine, try and find out how many pages are in the magazine and where the ad will be positioned. Material appearing in perfect-bound books with a great many pages requires more safety area to allow for the bind, or "creep"—this prevents your material from disappearing into the gutter (the inner margin).

2. If you know in advance that your single-page ad will print on a right- or left-hand page, tell your separator and prepare your boards to bleed on three sides only, rather than on all four. If, however, you have no guaranteed position, or if the same ad will be in several publications or will be printed in other ways (such as in brochures), you need to prepare your board to bleed on all four sides.

3. When preparing an ad to run in several publications, design the ad to accommodate the various trim requirements. Then be sure to include center marks, so the film stripper can prepare one master board for all the ads and then trim to the correct specifications for each publication.

4. When preparing an ad to run in several publications with different screen-ruling requirements, have the separator prepare the master film to the lowest screen ruling. All

publications can handle lower screen rulings, but some may not be able to handle film prepared to the upper limits.

5. If you are preparing a mechanical for packaging and carton work, consider using glue flaps to avoid additional stripping work when plates are made. If dyes are required, make sure there is an exact fit. Ideally, wait to have the dyes made until you receive your finished films. This reduces the possibility of the stripped films and the dyes not fitting exactly.

✔ TRADITIONAL ART BOARD PREPARATION

❑ Have a stat on your mechanical for every four-color image. Indicate *FPO* on each stat.

❑ Paste all type on the base board in black. Do not cut overlays.

❑ Double-check the accuracy of bleed, trim, and center marks.

❑ Double-check all elements for accuracy and cleanliness.

❑ Prepare a style sheet on any major project.

❑ Indicate holding lines by deckled stats, red lines, or written instructions.

❑ Indicate all outlines and drop shadows with rough tracing only.

❑ Give screen combinations for all PMS Matches.

❑ Indicate color breaks by using colored markers on your tissue overlay.

❑ When creating a large black background on a four-color piece, specify a 30 to 40 percent cyan tint under the 100 percent black—this will give a richer black.

7 HOW TO SAVE MONEY

The topic of cost savings is always difficult, since there is an inevitable quality loss that accompanies every cost-saving measure. The smartest buyers always have a clear idea of what they are trying to accomplish with their printed piece. Why are they doing this project? Why is it printed in four-color? To attract attention? Or, is it to be a product match? All of this must be clear to everyone on your staff before beginning the project, since subsequent decisions must be based on these important initial criteria.

It is a good idea to have a staff meeting to make this decision. Too often, a creative person has one idea in mind, the marketing people have another, the accounting and purchasing departments have still a different version, and then the production manager is left trying to keep everyone happy. Of course, everyone wants to have it all, but this is impossible. Even with an endless supply of cash, time constraints will tend to force you to accept a lower degree of quality than you would like.

Also, economizing measures in four-color film production must be seen in the context of the costs of the entire job. It is just not smart to save $100 on color separations only to have problems on press and end up being charged for additional press time.

GANGING

With these caveats in mind, there *are* ways to save money on four-color film production. The oldest method of cost savings is *ganging*. Ganging means doing more than one color separation at a time. You can save up to one-third of your color separation costs when you gang your input materials.

In order to gang, however, three conditions must be present:

1. The physical format of all materials in a given gang must be identical. That is, all the materials must be either transparencies, prints, or original artwork. You cannot mix transparencies and prints in the same gang. But you *can* gang a group of transparencies followed by a group of prints.

2. All elements in a given gang must be enlarged or reduced to the same percentage.

3. All elements in a gang must be compatible. Transparencies must be within a similar density range and have no obvious flaws. The sharpnesses of all the images should be similar, so that one sharpness setting will be sufficient for all elements in the gang. Transparencies of similar subject matter work best, since key color aim points will be similar.

As you can see, the overriding requirement for successful ganging is uniformity. On normal individual scans, many simple flaws can be easily corrected; in a ganging situation, however, this is impossible, since the operator will always be aiming for the lowest common denominator. In other words, the operator will make decisions about what is best for *all* of the subjects in the gang, rather than selecting the best settings to reproduce each individual subject.

Because of these compromises, along with the fact that most input materials need extensive work, ganging is not recommended for the high- or even medium-quality work. Reliable color separators will not indiscriminately gang subjects unless you instruct

them to do so. In fact, it is a good idea to consult the separator every time you are considering ganging subjects. For example, let's say you wanted to gang 10 transparencies. Go ahead and size them identically for ganging but then discuss their characteristics with your color separator. You may be told, for example, that to gang all 10 subjects would be terrible, but if the subjects were divided into two gangs, one of four and another of six, the results would be quite pleasing. While the two groups cost more than one, you will get better results and still save money compared to the cost of doing all 10 subjects individually.

Sometimes you may be very concerned about the color reproduction of one subject in the gang, but not care about the others. When this situation arises, tell the separator which subject is most important. The other subjects will probably not look great, but at least you should get a good reproduction of your critical subject. (Ideally, of course, you would be better off pulling your priority shot out from the gang and separating it by itself.)

The best ganging situation is when you have considerable control over the original photography. In a studio setting, where you can control the lighting and then send all the subjects to the film lab at the same time, you will probably achieve your best ganging results since you will have controlled every element prior to the separation stage.

To compute your ganging cost savings, refer to Figure 7–1. Because most color separators charge by the square inch for the film that they output, you can

7-1. This ganging chart shows how four 4 × 5 images can be separated at the same percentage—100 percent in this case—on one 8 × 10 sheet of film. In actuality, the images would be positioned tightly together, right next to each other, without the wasted intervening space. (Courtesy of Spectrum, Inc., Golden, CO)

10"

100% 100%

100% 100%

8"

see that ganging these four 4 × 5 subjects at 100 percent reproduction will produce an 8-by-10-inch sheet of film. Let's say our color separator charges $200 for this size film.

The separator will also charge a ganging fee of $15 per subject for the mounting time needed to put the elements in position on the scanning drum. The first transparency is included in the initial charge, but each subject after the first will be assessed the charge. In this case, there are three additional subjects, so the ganging fee is $45. This, added to the $200 film cost, makes the cost for all four subjects $245. This contrasts with the individual scan price of $100 per 4 × 5 scan, which in this case would total $400. Thus, the buyer in our example saved $155 on the color separation costs. Note, however, that doing four subjects in one scan did not even come close to reducing the costs by one-fourth.

In the next illustration, we can see the real cost benefits of ganging. Here we have nine 35mm transparencies, each one enlarged 130 percent. Since they are 35mm transparencies, their end size would fall into the color separator's minimum pricing of $100 each. Thus, if these were all done individually, the cost would be $900. If they were ganged, however, the end size would be 8 × 10 for $175 plus eight ganging fees at $15 each, for a total cost of $295, rather than $900. As you can see in this case (and in all cases with minimum-size separations and many elements in the gang), the cost savings can be over 50 percent.

PREPOSITIONING

Another variation on ganging is to *preposition* your transparencies or prints prior to scanning. With this technique, you save money not only on the cost of the separations but on the stripping or film-assembly cost as well. To do this, you will again need to have compatible materials being reproduced at the same enlargement or reduction percentage. Also, the subjects must be prepositioned very accurately, since the position will be fixed and you will lose all your cost benefits if you have to reposition an image individually later on (Fig. 7–2).

7-2. This chart shows how nine slides could be positioned for a gang scan. (Courtesy of Spectrum, Inc., Golden, CO)

PREPOSITIONING COPY FOR GANG SCANNING

The advantages of this technique are:

1. Lower cost separations when scanned as a unit rather than scanning each element separately.

2. Lower stripping costs. Prepositioning means that the entire flat can be handled as one stripping element.

3. It is easier to previsualize the flat with each element prepositioned. Any incongruities can be seen and eliminated at this point.

The disadvantages of this technique are:

1. Copies MUST be similiar in highlight and shadow values.

2. Some loss of quality must be expected if density curves of subjects don't match. By this we mean that if you gang 2 high-key (predominantly light) subjects with 2 low-key (predominantly dark) subjects, one or the other group will seriously suffer.

3. Alway remember that whenever we face a gang separation situation, we must use average or mean settings when calibrating the scanner. The options we have for manipulating the reproduction curve or color cannot be used when faced with several subjects because whatever we do to improve one subject will inevitably harm the other subjects.

TECHNIQUE

We are limited to a maximum size of 20" x 24" for the subjects. We would much prefer a maximum size of 19" x 23".

Our largest reproduction size is 25" x 38".

Transparencies should be mounted on "Super Transtay" resin-coated polyester sheets. This material has a tooth which prevents Newton's rings from forming.

Pick one of the short (16") sides as the TOP of the sheet.

All transparencies should be taped to the SUPER TRANSTAY on one side only. Put the tape on the TOP side. If you try to tape on 2 or 4 sides of each transparency, the assembly will buckle when it is wrapped around the scanning cylinder.

Transparencies MUST be clean when mounted. Any dirt, fingerprints, or scratches will be reproduced with absolute fidelity!

Lay the SUPER TRANSTAY on your light table. The resin coating is on both sides so it makes no difference which side is up. You should know that the resin coating is VERY easily scratched. Do not touch the plastic except when necessary.

Mount the transparencies so that their base is to the plastic and their emulsions are up, facing you. If in doubt as to the emulsion, try scratching the border with a razor blade. The side that scratches is the emulsion side. Remember, you want the emulsion side UP!

And again, apply one piece of transparent tape to the top of the transparency.

PRINTS are handled in much the same fashion. Mount them emulsion up with a very thin coat of rubber cement. We suggest you do not use hot wax for this purpose since the wax will not adhere well to the plastic.

Prints can be mounted on any *thin, flexible* surface that can easily be wrapped around the scanning cylinder. Most of our clients prefer to use SUPER TRANSTAY, or Mylar, or Acetate plastic sheets so they can easily mount to a standard grid or layout sheet.

When preparing the assemblies for shipping, SLIP-SHEET the separate assemblies with tissue and package them carefully. Any scratches that are picked up in shipping will be reproduced.

SPECTRUM INC.

Spectrum Inc.
"AMERICA'S COLOR SEPARATOR" ™

This example shows the typical requirements for effective prepositioning. (Courtesy of Spectrum, Inc., Golden, CO)

This technique usually works best with color prints, which are relatively easy to premount using a waxer, spray mount, or rubber cement. Position the prints on a sheet of white, smooth paper and make sure they are flat with no raised areas. Because there are compromises from using color prints and additional compromises because of ganging, this technique is best used for low-quality work.

If you wish to preposition transparencies for gang scanning, you should go to your color separator or to a duping lab to have the mounting done for you. Extreme caution must be taken, however, to make sure that the mylar mount is immaculate and that the images are positioned exactly. If there is even a small amount of dust on the mylar, the separator will charge you to reposition and clean up the work, which can be expensive.

A skilled technician in a duping lab can make complex local color correction to duplicate transparencies, which may be less expensive than the same corrections made on color electronic prepress systems. (Courtesy of Dynamic Graphics Educational Foundation workshops)

Again, do not use this technique for any high-quality work, as the results will be disappointing.

DUPING

Another common method for saving money, somewhat similar to prepositioning, is *duping*. In this process, original materials slated to appear together on a page or spread are sent to a duplicating lab, where they are reshot to their desired printing sizes and assembled into one composite Ektachrome image, which can then be scanned like a gang shot.

In addition to the eventual cost savings of scanning multiple images in one shot, duping offers several other advantages, including the following:

- The original input materials sent to the duping lab can be of any format, meaning that you can mix prints and slides—this is a distinct advantage over straight ganging or prepositioning.
- The original materials can also be reproduced at any percentage, since they will be made into one composite film—again, this is not possible with ganging or prepositioning.
- Although the original input materials again should be compatible and have similar highlight and shadow densities, certain color-correction and other image-adjustment work can be done as part of the duping process itself, eliminating the need for the same work at the more costly film-proof stage. Specifically, underexposed transparencies can be salvaged, color shifts can be corrected by filtration, local-area color correction can be executed, and poorly processed originals can be improved.
- Because the entire page is assembled with all images in their proper positions, there is a tremendous savings on stripping or film-assembly costs.

Duping, however, is not without its drawbacks: Ektachrome duplicating film cannot match the detail of the original transparency. The duping process also tends to increase total contrast while decreasing local contrast in the highlight and shadow portions of the image. Intense colors tend to get more intense when duped, while pale colors get lost altogether. Because detail is the most important element in determining the quality of color reproduction, duplicate transparencies, inherently lacking in detail, will not reproduce as well as original materials.

Duping prices vary widely, ranging from $25 to $100 per original transparency, depending on the skill and care taken during the process. With this in mind, a duplicating lab should be chosen with care.

The image on the left is an original transparency; the one on the right is a duplicate. Note the shorter contrast range and hot flesh tones of the duplicate. (Photographs courtesy of Gary C. Baker)

Separators often have their own facilities for this work, which offers the advantage of keeping the whole job under one roof. These labs, however, may lack the expertise of professional photo shops staffed with experts specifically trained in handling duplicate transparencies.

PREASSEMBLY TECHNIQUES

While ganging and duping can lower your separation costs, your stripping costs can also be reduced by using *preassembly* methods. This involves transforming your individual transparencies into a single page unit, so that rather than stripping several four-color images, the stripper only needs to position one large four-color image per page. Transparency assemblies are made by specialized photo labs, although some color separators also handle this phase.

Most buyers elect to use simple *cut-and-butt* assemblies. In this technique, the duplicates are cut and sandwiched together on acetate with special adhesive. Cut lines appear where the images touch, so

care must be taken in the design. Also, page units formed by this basic assembly method should not be used many times, since they tend to come apart after considerable use. This is the least expensive assembly method, however, and can work for most jobs.

Some buyers still use an *emulsion stripping technique*, in which the acetate layer on the duplicate transparency is dissolved and the stripper can then actually strip the base layer from the emulsion layer of the transparency. The thin emulsions can then be assembled on a new piece of acetate in a semiwet state, allowing them to butt completely and leave little, if any, evidence of cut lines. Then a new piece of acetate is placed on top of the entire assembly, completing a tight seal.

This technique allows the creation of montages and special effects. Images can be blended together to create vignettes. Also, there is a tighter seal, so the images do not come apart on the scanning drum even if the assemblies are reused many times.

Emulsion stripping, however, is very expensive—

so expensive, in fact, that today's electronic stripping systems are often more price-competitive and can do the work faster to boot. The electronic cost savings will become even more pronounced in the future, as costs of electronic systems go down relative to the labor and materials cost of hand-assembly methods.

A BETTER WAY TO SAVE MONEY

As you can see, each of these cost-saving methods brings with it a loss in overall quality. But many buyers overlook other effective cost-saving methods.

Color separators have two constant problems. The first is balancing the amount of work they have in the plant at any given time. As a job shop, a separator can do nothing until a client sends in work. This means that everyone in the plant is working overtime on some days, followed by periods of little or no work at all. Given this problem, try to give the color separator plenty of time to do an extensive project. With a lenient deadline, the separator will be able to use

your job as "fill work" for whenever the work load is light, thus improving the efficiency of the plant. In exchange for this, the separator should be willing to offer you a sizable reduction in price.

Also, color separators reward loyal clients. If you find a good supplier and have a high volume of work, talk to your color separator. If you feel confident about the relationship, draw up a written commitment for a certain volume of work during the next year or two years; your commitment will be rewarded with a reduction in price.

Finally, consider your cash-flow situation. If you are in a good cash position, you could offer to pay in advance for your work, or to pay within 10 days of invoice (rather than the usual 30). This offer should bring some reduction in price.

All of these methods give you cost savings without any decrease in quality. They represent the type of creative cost savings that should be used more often in this business.

Duplicate transparencies can be preassembled so that the entire page or spread can be scanned at the same time. This saves money on scanning and film-stripping charges. (Courtesy of Dynamic Graphics Educational Foundation workshops)

8 COLOR ELECTRONIC PREPRESS SYSTEMS

CEPS is an acronym for *color electronic prepress system*. These are all-encompassing digital systems that produce finished graphic arts films digitally rather than manually. CEPS systems handle all page elements in an integrated fashion, digitally processing the color separations, type, and tints, thereby producing film for a complete page or two-page spread.

The scanner (discussed at length in Chapter 3) digitizes an image, converting pictorial date into electrical impulses that are then fed into the CEPS system. The CEPS unit further divides the picture data into *pixels*, or picture elements. These tiny particles are recorded in the CEPS system memory according to their location, lightness, and color. The system then has the ability to deal with each of these tiny pixels of information as a separate entity, and therefore has the ability to manipulate each pixel's location, lightness, and color.

The first CEPSs were introduced by Scitex in 1980; similar devices were later manufactured by Hell, Crossfield, and DS. Each unit consists of four parts: a CPU (central processing unit computer), an input device (a scanner), a work station, and an output device film recorder (image-setting equipment). This configuration still exists today, although CEPSs have changed drastically over the years.

The earliest CEPSs were based on 1970s minicomputer technology. Like minicomputers, they were slow, and since they tried to do all tasks within one unit, they slowed down to a crawl when it came time to execute the final page. Today, the various tasks have been broken down into separate work stations, so that such functions as retouching and stripping can be done simultaneously in different work areas, leading to a more efficient work flow. Also, today's systems use microcomputers based upon the Intel chip, which results in faster processing of data. The newer systems have come down in price from their initial astronomical $1.5 million level to about one-third of that.

The reason prices are still high is that color printing requires a very high degree of resolution. All of the current systems are high-resolution devices, producing images of 65,000 to 90,000 pixels per inch. By comparison, desktop color monitors often display a low resolution of only 512 pixels per inch—not good enough for photographic-like reproduction quality.

Many buyers are amazed when they see a "simple and easy" CEPS demonstration at their local vendor, only to be charged a high price when they get the final bill. This is because although demonstration manipulation on the low-resolution color monitor is relatively fast, these images must be transformed into high resolution when the final films are created, which takes time and money.

Since their introduction in 1980, color electronic prepress systems have revolutionized the way color film is created. (Courtesy of Scitex America Corp., Bedford, MA)

Each CEPS workstation has a video monitor that shows what the job will look like in print. The monitors, however, use additive color, while printing uses subtractive, so the monitors are not true indicators of what will be seen on the printed page. (Courtesy of Scitex America Corp., Bedford, MA)

HOW A CEPS JOB IS PRODUCED

When your job enters a color prepress plant and has been designated for a CEPS system, it will be checked very carefully before the job is started. Shops often demand that all the elements in a job be presented at the same time, meaning that you must submit all the transparencies plus the art boards or disk as a unit. Sometimes a vendor will take batches on a large project, but, no work will begin on any page with missing pieces. Why such tight controls? Because system time is expensive, running between $200 and $1,000 per hour. The job must be able to run smoothly and efficiently.

The CSR at the plant will review your job carefully with you. The plant will often demand that you furnish FPO stats for each image on your page. These stats can either be done on a stat camera or on your desktop scanner. The stats must be to proper size and accurate in their rotation. Since there is so much pictorial data being manipulated, rotating or turning an image on a CEPS station is a very slow and costly process. It is often far more cost-effective (yet still expensive) to rescan an image than to rotate it even a small amount.

The CSR will also review any special color instructions and work you want done. There are many special effects and improvements to existing photography that can be done on CEPS systems, but you must be sure to specify them up-front and review them with the CSR before the job is started. Again, going back on the system for extensive work after the job has begun is a poor use of everyone's time and money.

You should also be prepared to discuss whether or not you will need your images or pages stored for future use. It also helps to know the largest size you will ever need for a given image, which can determine how the image should be scanned.

SYSTEM STAGES

Once the job enters the CEPS unit, the images will be scanned for maximum color fidelity. The scanners can handle all types of transparencies, color prints, and artwork, up to the input limits of the scanner. (See Chapter 3 for scanning details.)

After each image is scanned, it is reviewed by a trained operator on a *soft proofer,* or color monitor. These electronic images are low-resolution, so they do not reflect the actual color that will appear in print, but the operator is trained to interpret the image properly and to make small adjustments on the screen before committing the job to film or to the next production stage.

Once the scanner operator is satisfied with the image, it is transmitted digitally to the color work station. There, another operator, also highly skilled in color, executes any color manipulation or "magic" you have requested. If your job does not need specialized color manipulation, your job can bypass this station and go digitally directly to the film-assembly work station, where the operator will incorporate all the high-resolution files into the system and then create the final page, complete with type, tints, and the printing commands for trapping, bleed and trim requirements, and so on.

After all elements of a page are completed, the data are sent to a digital film plotter, where the low-resolution screen images of the scanner plus the color and stripping data from the work station are converted into the high-resolution films needed for printing. Because the final complex manipulations that convert all files to high-resolution film output take place at this stage, this final step is costly.

Once the job is output, it is reviewed again, to see that the films are correct, and then proofed for color fidelity. Once this is completed, the job follows the conventional path through the plant and is delivered to the client for final inspection.

CEPS offers some distinct advantages, including the following:

1. *Increased creativity:* Many CEPS techniques simply cannot be done any other way.

2. *Consistent quality throughout a printed piece:* All tints are identical, all elements are in perfect register and any future uses of an image will appear identical to the first.

3. *Cost-effectiveness:* For certain projects, such as advertising or catalog work, CEPS systems offer significant cost savings over the alternative of redoing photography at remote locations.

To alter a background color, the image first must be masked. Masking is expensive, but the results can be quite effective. (Courtesy of Scitex America Corp., Bedford, MA)

4. *Flexibility:* Multiple sizes and screen rulings can be achieved quickly and easily on the system. Done conventionally, the same applications would need to be done many times at a higher cost.

5. *Speed:* Especially for jobs involving multiple images and numerous tints, projects can be done faster and less expensively than by traditional hand stripping.

6. *Archiving and storage:* The use of digital data allows the reuse of images, even in different sizes and/or with different cropping, with identical color to the original.

8. *Superior proofing:* Proofs are often shown with all elements, including type, in place, enabling both client and supplier to see the interrelationship of all images, tints, and type on the page.

On the other hand, there are also problems with CEPS, including the following:

1. Because of the large amount of pictorial data involved, image rotation is expensive, so you must know an image's orientation before it is scanned.

2. Airbrushing large shadow areas is expensive.

3. Sawtooth edges sometimes appear on masks.

4. The low-resolution, soft-proofing monitor screens are not WYSIWYG ("What you see is what you get"), so what the operator sees on the CEPS screen is not entirely accurate. This can cause work to be redone for higher color fidelity.

5. Simple jobs (such as one with one image and two tints) are more economically done by hand than by CEPS.

6. All CEPS materials must be digital. Previously made or supplied films cannot be incorporated into the system—these jobs must be stripped conventionally.

7. Going back into the system for any reason, even for a minor change, is expensive, costing almost as much as the first time through.

ELECTRONIC MAGIC

Once your artwork has been digitized on the scanner, there are many special effects that can be achieved on the color work station. When these "magic" functions first became available, everyone was so excited that

In this example, rings were added to the model's fingers from other images. The CEPS can do this job so well that the new image appears natural. (Courtesy of Scitex America Corp., Bedford, MA)

they used them for everything—until they saw the final bill. Today, smart color buyers know that electronics is no substitute for good photography, and that these techniques are needed only when there is no other way to complete the job. There are several different types of color manipulations:

1. *Tonal gradation:* This process adjusts contrast, so that you can add weight to shadows, open up highlights, or adjust any point along the reproduction curve without affecting the other areas. Note, however, that this technique can often be executed cost-effectively on a non-CEPS scanner (see Chapter 3).

2. *Selective color correction:* This process alters the color balance to achieve the desired result. Sometimes a simple overall color change is all that is required, but the work can also be quite specific. To change a particular color area, the operator electronically masks out the areas that do *not* need correction and then makes the necessary adjustments to the remaining area. This is usually best done via CEPS.

3. *Retouching* (also referred to as *electronic airbrushing*): This is done to make simple changes like removing telephone wires from across the sky, eliminating flaws from transparencies, and so on. The retouching can be either transparent or opaque. Depending upon the job, this can be inexpensive or very costly.

4. *Cloning:* This is a form of retouching in which the pixels themselves are relocated within the image, so that portions of the image are either repeated or transported. This process can correct facial flaws, add leaves to trees, move a ball from one area of a playing field to another, or perform other complex functions.

It is possible to completely alter the color of the model's shirt on the CEPS system. This capability can be very important when photography cannot be reshot. (Courtesy Scitex America Corp., Bedford, MA)

Pixel swap, or cloning, permits retouching of this model's face and the addition of eyeglasses from another transparency. (Courtesy of Scitex America Corp., Bedford, MA)

The original background of this shot has been replaced with that of another transparency. Blur-brushing the edges where the two shots meet makes the new image look lifelike and natural. (Courtesy of Scitex America Corp., Bedford, MA)

5. *Sharpness enhancement:* When the degree of sharpness in an original image is lacking, a skilled operator can make the image appear crisper by accentuating the pixelization and thus improving the perception of sharpness. Sometimes this can be done inexpensively on a non-CEPS scanner (see Chapter 3).

6. *Blur brushing:* In this process, sharp edges between picture elements can be softened, creating a soft vignette that makes the image appear more lifelike. This must be done in high resolution and can be time-consuming and expensive.

7. *Ghosting:* This process superimposes one image over another. This can only be done on a CEPS system.

8. *Combining and changing images:* The system has the ability to swap pixels, not only within an image, as in cloning, but also between images. Thus, you can combine the background from one transparency with the models from another and the props from yet another to create, in essence, an entirely new image. This is extremely time-consuming and system-intensive, since everything must be done in high resolution, and often only a portion of the complex task can be shown on the screen at one time.

9. *Outlining:* The system has the ability to outline or drop out a background. This is often done on a CEPS system but is not an effective use of the system, since often it takes just as much time to execute a CEPS outline as it does to do it by hand. However, if you know that you are going to outline a subject, you can avoid the high charges by photographing the subject clearly differentiated from its background—a white subject against a black background, or a dark-haired person against a white or light-gray background, for example. This makes it possible to do the outline with a density mask. In essence, the operator tells the system to drop out the lighter or darker areas, leaving the higher-density subject intact. If the density mask is imperfect, the operator can remove pixels, but this is still faster and therefore cheaper than the regular mask (a good use of the $5–$50–$500 principle).

ARCHIVING AND STORAGE

In the past, film storage was the norm. A color shop produced final films and kept the working elements of the job, so that if you need additional sets of films or wanted to reuse certain elements of the job later, they would be available.

Now, however, with electronic film assembly, there is only one set of film, which is sent to you. It is the electronic working elements of the job that must be archived for later use. Initially, data will be stored on magnetic disks, but these are too expensive for long-term storage, primarily because there is so much data to be stored. The average four-color 8½-by-11-inch page, for example, has 25 to 90 megabytes of information—a single page can take up almost an entire magnetic tape, which is the typical storage medium. If you think about all the pages that are produced, all the images involved, and all of the corresponding data, you can see what an involved task storage becomes.

Nonetheless, magnetic tape is the medium of choice for most long-term storage. Magnetic tapes have other problems, however: If the tapes are not stored properly and run regularly, they can deteriorate over time. Also, tape can stretch or shrink, again damaging your information. And even the fundamental force of gravity pulls down the tapes slightly, which can cause damage.

Despite these caveats, most good color houses report little damage to their stored tapes. A bigger problem, however, is that tape is a sequential storage medium—to address a certain portion of the tape requires reading through the preceding data. This is very time-consuming, and thus on a large project with many pickup images, the separator often will ask the client to furnish pickup information in advance, so the data from the various tapes can be reassembled on new tapes, ready for input into the system.

Once the technology becomes affordable, future advancement will come from optical disk technology. An optical disk works like a CD and can offer higher-density storage in a smaller space. Also, because the disk can be randomly accessed, data can be picked up from any area without the cumbersome task of reading through the entire disk to locate the proper portion.

DATA TRANSMISSION

The prospects of four-color data circling the globe via satellites is appealing, and conjured up high-tech visions of a vast communications network. The realities, however, are that there are many obstacles to overcome before this is possible.

The biggest problem is the amount of data that must be considered. A full-page can take from 20 minutes to over an hour to send over a satellite, a monstrously expensive proposition given the realities of satellite-time charges. This is because the individual page can have over six million pixels comprising the images. (To put this in perspective, it would seven hours to transmit the same data over phone or fax lines.) Because of this problem, it is necessary to compress the data. This is done by averaging the pixels, so that the fundamental nature of the image is retained with fewer pixels to be transmitted. Then the process must be reversed at the other end, so that all the original data is stored. This enables magazines like *Time* to transmit their data relatively inexpensively over satellites—an entire issue of the magazine can now be transmitted in a few hours.

The costs for this technology, however, are far beyond the reach of most buyers. Building and deploying a satellite requires a $100 million investment before it even produces any revenue for its owners, making purchase prohibitive and leasing time correspondingly expensive. For most transmissions, therefore, the 9,600-baud telephone line, though relatively slow, is still the data-transmission technology of choice.

Other CEPS-related issues include *digital proofing* (see Chapter 10), which is not yet sufficiently developed to represent the proof of choice for contract color requirements. Once this technology becomes more mature and cost-competitive, there will be faster assembly time, bringing down the overall cost of CEPS films.

Finally, there is the moral issue of standards for electronics. We now have at our disposal the ability to alter images so accurately that it is possible to deceive or defraud. Consider, for instance, a court case that hinged on printed pictorial evidence—what if cloning or other image manipulation had taken place, changing the essence of the original picture? Professionals in the color reproduction industry need to recognize and act upon their shared responsibility to ensure that the wonders of the technology at their disposal are not directed toward ethically suspect ends.

9 DESKTOP COLOR

As we approach the 21st century, we look toward a color world that is rapidly changing. The development of the early computers of the 1960s gave rise to color scanning, which became the cornerstone of our current color prepress technology, starting an evolution from a craft-dominated industry to a technology-driven enterprise that has given rise to CEPS and now to the concept of electronic or desktop publishing.

It seems hard to believe, but desktop is a relatively new phenomenon, born out of a tiny microchip. The Intel 286 chip ushered in the IBM personal computer in 1981, which was followed in 1984 by the Apple Macintosh. Prior to these inexpensive yet powerful computers, the concept of electronic publishing was unheard of, because it was too expensive to use the existing minicomputers for graphic design applications.

Early desktop efforts were crude and cumbersome—as in any burgeoning industry, there was tremendous confusion and misinformation as this new phenomenon came on the scene. The first programs were very difficult to use, yet many people mistakenly believed that anyone could suddenly become an art director, typographer, or designer merely by sitting behind a computer terminal with a graphics package in hand. Longtime design professionals cringed, as documents were produced in a mishmash of every possible type style, usually with confusing overall designs. Skeptics were quick to write off desktop as junk and dismiss it as unsuited for the true professional.

As the professionals turned their backs on desktop, however, a new type of graphics professional embraced it. These people, often emerging from disciplines far from the graphic arts, began to experiment with the new technology. Their first efforts were simple—church bulletins, fliers, and announcements—but they soon got better and more ambitious. The software improved as well, and suddenly there were desktop projects that were indistinguishable from their traditional counterparts.

Once they saw the new possibilities shaping up around them, even the more dubious graphic professionals realized that desktop was a wise market to pursue and quickly enrolled in courses to update their skills. Most found that the desktop "restrictions," which they thought would impede their creativity, actually expanded their design talents.

The computer capacity once available only in large 1970s computers has now been packaged into small, modern desktop units. (Courtesy of Spectrum, Inc., Golden, CO)

Now, with the widescale acceptance of desktop and the development of good page-makeup programs, such as Pagemaker, Ventura, and Quark, and the introduction of color desktop monitors, graphic designers have sought to incorporate color into their desktop projects—this is the new desktop horizon.

WHAT IS DESKTOP COLOR?

As discussed in Chapter 2, there are two different types of color: tint, or flat color, and continuous-tone images. (Unfortunately, many desktop users erroneously refer to the screen breakdown of flat tints as "color separations," confusing them with the true separation process.) Tints are relatively easy to reproduce on the desktop; halftone reproduction of continuous-tone images, however, requires a lot more computer capacity and manipulation capabilities than present desktop systems allow.

Desktop tints are relatively manageable because tints have distinguishable boundaries that separate the tint tone from other data—each individual tint is distinct, making it easier to manipulate. Desktop tint

reproduction has some limitations, however. First, a color monitor will not show exactly what color a printed image will look like. The monitor, while it can approximate the printed result, uses additive colors, while the printing process uses subtractives. Also, the color on the screen is *transmitted* light, while a printed piece is seen as *reflected* light.

Adding to the problem is the poor trapping capability of many desktop programs. (Trapping, you will recall, is a prepress technique that improves image registration.) Traps are a necessary part of a job running correctly on press, but are either unavailable on desktop programs or require a thorough knowledge of printing in order to execute correctly. Even with this expertise, incorrect trapping cannot be detected on a low-resolution desktop monitor or even on a high-quality proof, meaning that a job could have big problems without anyone realizing it until too late. For this reason, many designers use the color desktop capabilities only for spot color, when there is no trapping needed. This problem should be addressed by future software updates.

This page is composed of only type and tints. This can be done on the desktop, but it is still necessary to trap the tints and type. Newer desktop programs have this capability. (Produced using Quark XPress)

Desktop struck a damaging blow to the type industry, allowing everyone to set type on their computers. As font selection increased, it became clear that few, if any, typesetters were needed. Many typesetters went out of business, but those with foresight bought image-setting equipment to transform desktop output into high-resolution films. These devices, costing $50,000 and more, were (and are) too expensive for most desktop users to purchase for themselves. They became the basis for the emergence of the modern *service bureau*.

Although these companies specialize in outputting computer files as film via laser image setters, such as Linotronic or Compugraphic units, they also do more. For instance, most offer advice and training, some sell hardware, some sell software, and they have combined to become an overall networking place for the desktop community. Because service bureaus are young, however, they differ vastly in their quality levels. Many are staffed by computer buffs who have no concept of color-related instructions like "maintain density levels" or "calibrate monitors." Their graphic arts background tends to be minimal, and often they have entered the business from fields as diverse as engineering and programming.

SELECTING A COLOR SERVICE BUREAU

Because most service bureaus grew out of non-color-related businesses, they often lack color expertise. To find a good one requires homework and careful evaluation. Here are some criteria to use:

1. *Do they produce film or paper output?* If the majority of a service bureau's work is paper, they probably lack the expertise to examine films for flaws and problems. Paper is far more forgiving and does not require the calibrated equipment and expertise of film output.

2. *Can they support your software programs?* Does the service bureau have the same version of the software that you have? Do they work with your software on an ongoing basis? If they do, they can help you through problems; if not, you're on your own.

3. *Do they have experience?* How long has the service been in business? Find one that has been in business for over two years.

4. *Do they guarantee that their films are in register?* Many service bureaus are careless about maintaining the accuracy of their image setters. To work with overlapping colors, you need film that is registered to within two-millionths of an inch.

5. *Do they have a densitometer?* A densitometer is a light-sensitive device that measures the light transmitted or reflected by paper or film. It is used to check the accuracy and quality of film output. (See Chapter 11 for further discussion of densitometers.)

6. *Do they have high-quality prepress proofing?* Make sure the service bureau uses one of the contract proofing methods (at least Color Key or NAPS); otherwise, you will have no idea of what your job will look like before it goes on press. Confirm that your printer is familiar with and will accept the service bureau's proofs.

7. *Can they provide a list of references?* With any vendor, regular clients are the best indicators of the company's commitment to quality and service. When checking these references, make sure to ask specifically about color work.

DESKTOP PROCESS COLOR

A four-color page has two separate elements: scanned images and page geometry. The page geometry, or mechanical layout, contains the type, tints, and overall structure of the page. In the past, transforming the page geometry into finished film was done by a stripper; today, almost all of these functions can be done on a desktop system.

Four-color, continuous-tone image reproduction, however, is still beyond the practical limits of the desktop world, although these limitations haven't stopped some software developers from suggesting otherwise—almost every day brings yet another new software program, promising yet another "breakthrough" that will offer you full-color reproduction from a $595 program. And every month, yet another computer magazine proudly

The page geometry, or stripping characteristics, of this page were input on a desktop unit. All color elements are flat or tint colors, making the task acceptable for total desktop production. (Produced using Quark XPress)

shows what it was able to produce on a desktop system. Looking at the desktop image next to high-end CEPS output, it is easy to believe that the two are not that far removed from each other.

There is a lot of untold information in these experiments, though. The magazines, when asked how long it took them to achieve their proudly displayed desktop images, often admit that it took them an entire day to reproduce just one transparency. In fact, they had to reject many transparencies to find one that was almost perfect before even getting that far. Does this sound practical for you? Trial-and-error experimentation is just too expensive for anyone with deadlines to meet and many projects to complete. Despite the claims of software manufacturers, the necessary expertise for four-color images is yet to be incorporated into prepackaged software.

WORKING WITH A COLOR SEPARATOR

For all these reasons, most color buyers go to a professional color separator, because the separator will be reproducing the four-color, high-resolution images that will go into the film. Moreover, any good trade shop will be very skilled in examining film, providing accurate proofs, and meeting the needs of your printer.

There are several ways to deal with a color trade shop on four-color desktop projects involving color separations. Obviously, you can continue to provide transparencies plus traditional art boards, which the separator can separate and then strip either by hand or electronically. In either case, the separator will take full responsibility for the end product, but you will continue to pay a high price both in terms of time and money.

You may wish to use your desktop system to complete the page geometry and then send your output to a service bureau for image setting. This should save you money over the cost of typical traditional mechanical preparation, but you must prepare your work so that you will have no problems at the color separator. Tints that do not overlap four-color images (i.e., those that lie on a white background) usually will not cause any problems other than color discrepancies, but if a tint area traps or overlays a four-color image, or if it needs to trap into another tint, there may be moiré problems, which the separator will be unable to correct without discarding the supplied films. This is why many separators will advise their clients to send them type output only, and to let them strip in the tints as well as the four-color images.

LINKING TO A HIGH-END SYSTEM

You can also investigate the possibility of direct input into the CEPS system at your trade shop. There are two different program methods you can select: proprietary or nonproprietary. These programs allow you to link your disk directly to the color separator, eliminating the need for mechanical art boards.

To use a proprietary program, you must decide which high-end system to link with. Scitex, the widest-selling high-end equipment, has developed Visionary, an expanded version of Quark XPress, which can link your desktop output directly to Scitex systems. The software for the system, which feeds into a MacIntosh only, can be obtained for free, in exchange for a very long-term contract, or for up to $3,000—the actual cost of the software (you must still buy the necessary hardware to support the system, however).

At the separation plant, a work station called the Scitex Gateway takes your Visionary file and converts it into a new electronic mechanical that can be read and accepted by the Scitex system. Your Visionary page can have low-resolution scans for each of your four-color images, which can later be replaced by high-resolution scans ready for printing. These high-resolution scans will be made on the separator's traditional scanners and then incorporated into the final films. In another variation, the Scitex color trade shop can scan low-resolution images for you earlier in the process, and then send these files back to you for inclusion with your electronic mechanical, a process known as *automatic picture replacement*, or *APR*. Also, your color separator will take overall project responsibility, help train you and your staff, and offer backup and advice if problems arise.

Scitex also offers V.I.P., a nonproprietary universal interpreter solution for translating desktop Postscript into Scitex language. If you select this route, you do not need to purchase specialized programs—your regular Postscript files can go through the Gateway and be converted into Scitex language. Because the links are not as strong as those with Visionary, however, last-minute revisions are more difficult. On the other hand, you can select the software that best meets your needs and update your software as better programs come on line.

Crosfield Electronics, part of Du Pont Electronic Imaging Systems, has developed Studiolink, which links desktop users to the Crosfield studio systems. With Studiolink, you use a prepackaged program, Ready Set Go, to transfer directly to the Crosfield system. You can also select Letraset's Design Studio in the same way. In either case, there is a Sun SPARC work station at the color separator and a Hyphen RIP Postscript interpreter that can convert the files to Crosfield language. The latest release permits other software, such as Quark, PageMaker, or Ventura Publisher, to interface, although not as easily. Studiolink follows the same procedures as Visionary for getting high-resolution images into the system.

Hell Graphic Systems took a different approach when devising ScriptMaster, their desktop link. Rather than being tied to any specific desktop program, ScriptMaster is capable of taking any Postscript program and working with it. It also uses a Hyphen RIP Postscript interpreter running on an Apollo 3500 work station. Like the other two programs, high-resolution images are handled on the scanner and then linked to the page geometry.

The trend is toward nonproprietary links to high-end systems. This is probably the best situation for desktop users, who will be able to select the software

Most four-color desktop users want to link their production to a high-end prepress system, such a Scitex. In this link, the designer does the page geometry via a desktop computer and then sends the disk and transparencies to the high-end trade shop for high-resolution scans plus final film and proof output. (Courtesy of Scitex America Corp., Bedford, MA)

that best meets their needs without permanent ties to prepress color vendors, and to change programs as technology changes without paying any more than necessary.

SUBMITTING AN ELECTRONIC MECHANICAL

When linking to a high-end system, you will be sending the color prepress house your transparencies, color prints, and artwork plus your disk. The electronic mechanical, however, presents new challenges. Before sending your job, make sure you consider the following:

1. Are crop marks and registration marks included on all files?
2. Are the image dimensions (including indications of bleed and trim) accurate on all pages?
3. Have you done any trapping? If so, are images trapping properly?
4. Submit a hard-copy proof and mark all pertinent information, just as you would on the tissue of an art board (see Chapter 6 for details of preparing

the tissue). Alternatively submit a color thermal proof.

5. Make sure your color trade shop has all the fonts for your job.
6. Make sure your color trade shop has the same version of all programs you are submitting.
7. If you are working with encapsulated Postscript files, always supply editable versions. If you do not provide this information, it becomes more difficult to troubleshoot your job.
8. It is a good idea to give all reverse type a special tint value, and to explain this to the color house. Sometimes an FPO file can be stripped out of the desktop file, and the white type then will not be seen.

After reviewing your files, make sure you give the color separator the following materials and information:

- Platform (IBM or MAC) plus model number
- Software programs (including versions) on submitted files

It is always difficult to see a color on a desktop monitor and then translate it into what you will see in print. With this problem in mind, the new PANTONE Process Color Simulator 747XR CMYK Edition gives you the desktop equivalents to the PANTONE colors. (PANTONE® is a registered trademark of Pantone, Inc.)

- Fonts submitted, including brand name and font name (e.g., Adobe Helvetica Bold)
- Number of pages in the document
- Page size, including breed and trim sizes
- Scaling—100 percent or other
- Line screen needed
- Film type (negative or positive, emulsion-up or down), and the total number needed
- File names for all elements
- PostScript special effect used, if any
- Whether you want crop marks or registration marks to appear on your films
- Inventory of hard-copy elements included (transparencies, artwork, etc.)
- Type of proof required

Desktop links are not perfect. Programs such as Adobe PhotoShop and Letraset's ColorStudio let you manipulate your own images, but you must do this on your desktop unit in a high-res mode. This means that the color trade shop must pass these files to you in a high-resolution format, which means the trade shop must either use up valuable and expensive space storing your high-res files or somehow manipulate these computer-intensive files, which is cumbersome at best.

There are other limitations as well. Many high-end systems cannot handle more than 124 layers (a layer is a color) per image or more than 256 colors per page. This means that complex blends must be forsaken, or that you must rely upon the high-end resolution system to create the blends for you, which defeats the purpose of the desktop link—allowing you the freedom to do much of the work yourself.

Because of these problems, many of which are certain to persist for quite some time, anyone using desktop color must be very flexible and tolerant of constant change. Also, since these are uncharted waters, you will always need a backup plan for getting your work done—this backup may be your color trade shop's desktop system or someone else's. In any case, be prepared to be resourceful—the likelihood is that you'll *have* to be.

10 EVALUATING COLOR PROOFS

A proof is the representation of what your job will look like in print. Produced under tight quality-controlled conditions, your prepress proof should serve as a guide to the pressroom and as an unofficial contract between you and your color supplier. Under this unwritten contract, it is assumed that what is on the proof is also on the film, and that corrections made to the proof will be reflected in corresponding changes made to the film. (These "contract proofs" must be distinguished from the design proofs made at the comp stage or at other stages of the preproduction cycle. Comp proofs are not accurate

color proofs. They closely resemble what the final product will look like, but they do not show you what your job will *actually* look like in print. Many new thermal- and laser-image color proofs fall into this category.)

I've seen many buyers look at proofs and agonize over them—especially the first color proofs. They usually compare the proof to the transparency or original art, and when they see that the proof does not replicate the original, they feel something is wrong. Adherence to the original, however, is not necessarily the best standard for judging color

An accurate contract proof is a close representation of what your job will look like in print. (Courtesy of 3M Printing and Publishing Systems Division)

Marking "Progs" and Proofs for Good Results

Marking "progs" is one of the most difficult jobs an artist can have dropped in his or her lap without some instruction in how to mark them. But young artists are not always trained to mark "progs," and their first experience comes when the customer needs help. The customer naturally calls upon the artist who is expected to know and understand.

"What's a prog?" might be the young artist's first comment. "Prog" is a slang term for progressive proof, which is a set of proof sheets that show the progression of the printing from the first color laid down to the final four-color sheet.

The standard "prog" is usually made up in the following order:

Yellow Sheet
Cyan Sheet
Yellow and Cyan Sheet
Magenta Sheet
Yellow and Magenta Sheet
Cyan and Magenta Sheet
Yellow, Cyan and Magenta Sheet
Black Sheet
Yellow, Cyan, Magenta and Black Sheet

Of course, there are other combinations that can go into the "prog," such as the yellow and black, but this is the general breakdown of a standard "prog."

The reason for the "prog" is to permit printers and their customers to evaluate the printed sheet when considering corrections. Sometimes when viewing a four-color sheet it is difficult to know exactly which color is the offending color when certain process colors are not right. For example, a process green may be off-color and a snap judgment may decide that the cyan is too strong when in reality the yellow may be too weak. The "progs" permit a comparison of the single-color or two-color sheets to determine which is the offending color.

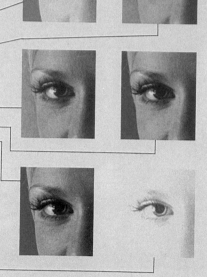

separations. The readers who see the end product will not have seen the originals—why not look at your proofs in this same context? If your proofs are pleasing, sharp, and generally appealing to the eye, it is often best to let it go at that instead of agonizing over achieving a perfect match with the originals. This also saves money on correction costs.

PREPRESS PROOFS

Prepress proofs can be divided into several major categories:

- *Press proofs (also called progressive proofs):* These are produced on a printing press.
- *Laminate proofs:* These include single-sheet proofs, such as Cromalin, Matchprint, Agfaproof, ColorArt, Pressmatch, and Signature.
- *Overlay proofs:* These are acetate overlays, such as ColorKeys or NAPS.
- *Soft proofs:* These are digital proofs displayed on color monitors.
- *Digital proofs:* These are rough color proofs, such as Iris, 4Cast, QMS, and Colorscript, and newer contract proofs, such as Digital Matchprint and Approval.
- *Bluelines:* These are single-color proofs for checking position only, such as Dylux, brownlines, and book blues.

PRESS PROOFS AND PROGS

The oldest form of proofing is the press proof. In this procedure, the film is actually made into printing plates and a short-run printing job is done on the press, leading to progressive proofs (or "progs"). A prog is actually a series of proofs, one for each process color—so there is a magenta proof (which represents the magenta film), a cyan proof, and so on, allowing you to see the color level for each plate. Further proofs in the prog sequence show the two- and three-color combinations. The entire prog for a given image (or page or spread, depending on how the proofs are arranged) is stapled together, with the top sheet, or press proof, showing all four colors.

These proofs must be created under strict quality-control measures. Since the press is actually used in this method, it is important to use inks and paper that match (or at least resemble) the materials that will be used when running the final job—using anything less is a waste of press time and effort.

Today, press proofs are usually used for national ads or very-long-run four-color jobs. Press proofs are also the most economical method for projects requiring five or more sets of proofs, but most jobs require less, and press proofs have been declining in use for a number of years.

If you are using press proofs for an extremely high-quality four-color piece, such as an annual report, you probably should have proofs made by the sheetfed printer who will be printing your job, rather than by the separator. This will ensure that the same paper, ink, press, and press personnel will be doing both the proofing and the final run, making the proofs a true preview of the press run.

The main advantage of this method is that you see an actual press run, rather than a simulation, as in off-press proofs. This means that when you review the proofs, you are actually seeing the interaction of ink on paper, including ink trapping. Press proofs, however, are expensive. Also, for economical reasons, press proofs must be generated on a sheetfed press, but most long-run jobs are printed on a web press, which means the press proof and the final job really are not comparable. Finally, off-press proofing methods have improved to such a degree that they are now extremely accurate, which, given the economics of the situation, explains why most buyers have abandoned press proofs.

LAMINATE PROOFS

Most color buyers today use off-press proofs, of which there are several types. First are laminate or single-sheet proofs, which look like the printed piece.

Today, all laminate proofs can be made on either a commercial- or publication-base stock. The commercial-base option should be used for jobs to be printed on a sheetfed press with good-quality paper stock; the publication-base stock more closely resembles the press characteristics of a web paper, and therefore should be used for jobs that will be run

Laminate proofs, such as Cromalins or Matchprints, are the most widely used prepress proofing products. (Courtesy of Du Pont Printing and Publishing)

Making a Cromalin begins by placing the film for one of the process colors in contact with a laminate sheet and exposing it to ultraviolet light. (Courtesy of Du Pont Printing and Publishing)

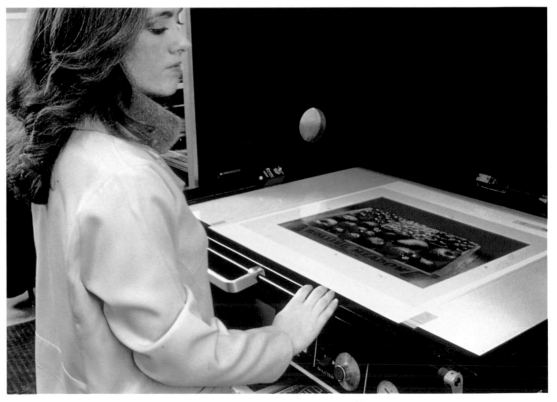

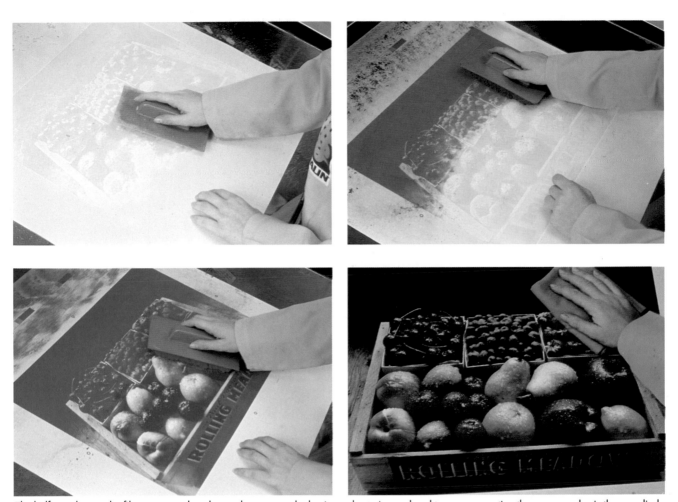

The halftone dots on the film are reproduced as tacky spots on the laminate sheet. A powdered toner representing the process color is then applied. These steps are repeated for each process color, ending in a simulation of the final printed piece. (Courtesy of Du Pont Printing and Publishing)

on a web press. All the laminate methods to be discussed here can work with both negative and positive films.

One brand of laminate proof is Cromalin, a trademarked product of the Du Pont corporation. Cromalins are made through an additive process in which colored powdered toners—one for each process color—are applied to a laminate base to build up the color, much in the same way that colored inks build up the color on the final printing substrate.

First, a laminate layer is applied to a heavy white paper. Then the printing film for a given process color—yellow, say—is put in contact with the laminate and sealed in place with a vacuum frame. This is then exposed to ultraviolet light, which causes a reaction on the laminate—the printing dots on the film are reproduced as small, tacky dots on the

laminate surface. Then the frame is opened, the film is taken away, and the yellow Cromalin powder is applied to the laminate (sometimes by hand, more often by an automatic powder-dispensing machine). Because the tacky dots match the printing dots on the yellow film sheet, the yellow Cromalin powder adheres only to those areas; excess powder is wiped away. Then process is repeated for the remaining process colors, using the same sheet of heavy white paper, until all four color levels have been applied. A final seal is applied at the end to keep the powdered toner in place. The result simulates a printed piece.

Cromalins are difficult to make but are very accurate color proofs. Many buyers prefer them because they can be formulated to match the printer's particular ink set exactly. If fifth or sixth colors are used in a job, additional Cromalin powders can be

added to the process. Also, Cromalins are good-looking proofs with high buyer acceptance.

Cromalins, however, are subject to great fluctuations. Generating two Cromalins from the same set of film can actually produce two entirely different results, depending upon just how much powder is applied, although this is less of a problem when the powder is dispensed by the machine. Also, although Cromalins have great appeal because their colors tend to look bright and punchy, which is what people like, this is usually a false impression—the laminate layers tend to add color intensity that will never be achieved by ordinary printing inks on a printing press. Buyers looking at Cromalins should remember that the color will be slightly diminished on the final printed page.

Similar to the Cromalin, and often called by the same name, is the Matchprint II proof, a trademarked product of the 3M Company. Unlike Cromalins, which use an additive process, Matchprints use a subtractive process: Predyed acetate layers are stripped of unwanted color to replicate the final printed page.

As with a Cromalin, a Matchprint starts with a heavy white sheet. Each film level is put into contact with a predyed acetate sheet that resembles the ink color for the film being used. The acetate and film are then sealed in the vacuum frame and exposed to light, just like in the Cromalin process. The reaction, however, is different—the printing dots on the film are replicated on the acetate, which is then removed from the frame, separated from the film, and run through a special processor that removes the colored acetate layer from all areas of the sheet except those matching the printing dots on the film. This is then repeated for each of the remaining process colors, leaving a proof that resembles the final printed project.

Matchprints are attractive, accurate proofs with wide buyer acceptance. They suffer from the same drawback as Cromalins, however, since the proofs can often look better than the final printed product, primarily because the acetate layers add color intensity that cannot be achieved with ordinary

Matchprints use a subtractive process that removes color from all nonprinting areas. The acetates are then laminated together and the final result looks like the printed piece. (Courtesy of 3M Printing and Publishing Systems Division)

printing inks. Also, Matchprints have a weak black, which gives a false impression when viewing shadow areas. This can present particular problems for jobs with heavy undercolor removal, since this inaccuracy in the midtone-to-shadow areas will not show what the job will look like in print. For this reason, many separators use every trick possible to try and boost the impression of the Matchprint black. The danger, of course, is that the separator may actually boost the black on the film, which will cause printing problems in spite of a great-looking proof.

Matchprints do give more consistent results than Cromalins, because the dyes are fabricated in a factory-lab environment instead of being applied in a trade shop. Since color is then removed, rather than added, Matchprints are easier to make and therefore less dependent upon the skill of the operator making them. Because the acetates are prescribed colors, however, they lack the flexibility for individually formulating specific colors, as can be done with Cromalin powders.

Some buyers request Matchprints with a deglosser applied. The low-gloss proof more closely approximates the final printed result, but gets a lower level of buyer acceptance. 3M has also introduced the transfer system which enables the Matchprint to be made on the exact stock your job will print on.

Other laminate proofing systems include the Agfaproof, which is similar to Matchprint. Agfaproofs are made with a low, medium, or high dot-gain factor built into them. This is an attempt to simulate on-press dot gain, but is not accurate enough to show what the actual job will look like.

The Fuji ColorArt color system is another laminate system based upon subtractive technology. Because it is comparable to Matchprint but overcomes the weak-black problem, it is growing in popularity.

Your printer may be familiar with a new proofing system called the Kodak Signature system. Signature is based on liquid electro-photographic technology (LET). It uses toning inks derived from actual ink pigments. To produce the proof, electronically charged film attracts these toning inks, which are then transferred by heat and pressure onto the actual printing stock. This proof offers the added advantage

of being able to produce a proof on both sides of the sheet. Unfortunately, it requires a large, cumbersome system that is inefficient and expensive to boot.

All laminate proofs are expensive to make. If an error is made anywhere in the process, the entire proof must be destroyed and redone from scratch. The materials costs are high—the proofing material often costs more than the film used to make the proof.

OVERLAY PROOFS

Although most four-color proofing today is done on laminate proofs, the earlier overlay proofs still have value and are used extensively. The best-known brand of overlay proof is the 3M ColorKey. It is so well-known, in fact, that many graphic arts professionals mistakenly use the term "color key" to describe *any* brand of overlay proof.

The 3M ColorKey process is similar to Matchprint. For each of the four process colors, the film is exposed to colored laminate material corresponding to the colored ink, resulting in colored dots that remain on the colored acetate when the rest of the color is removed.

After the exposures are made, however, the acetate layers are not laminated together. Instead, each color is hand-registered to the next and mounted on a carrier sheet. The final result is a series of transparent colored acetates in register, rather than one laminated piece.

ColorKey material comes in a wide variety of specialty colors. For a job requiring a special or fifth color, a special overlay indicating the color break in the specified color (or something very close to it) is available.

Because the ColorKey acetates are not laminated together, they tend to appear dull and lifeless. Also, there is a yellow cast, which results in some color distortion and adds to the dull impression.

Another popular brand of overlay proof is the American Hoescht Corporation's NAPS proof, an acronym for *negative-acting proofing system*. NAPS is as popular as ColorKey, although sometimes unintentionally so—since "color key" is often used generically, buyers often say they are looking at color keys when, in fact, they are reviewing NAPS proofs.

NAPS proofs, which are similar to ColorKeys, are overlay proofs consisting of four colored acetates. NAPS acetates are taped together rather than laminated. (Photo of NAPS® proofing system used with permission of Hoechst Celanese Corporation; NAPS® is a registered trademark of Hoechst Celanese Corporation)

In any event, NAPS proofs are very similar to ColorKeys, and it is difficult to tell the two apart. They are made exactly like color keys, but are thicker, making the dulling factor even more prominent, but also making NAPS proofs easier to handle and evaluate.

When looking at any overlay proof, whether ColorKey or NAPS, try to get the overlays as flat as possible. If you lift up the top layer—the black—you will get a better idea of the intensity of the other three colors, since there will be one less dulling acetate sheet to contend with. Many buyers also apply film cleaner to each layer to minimize the dulling factor. In any case, however, the color on an overlay proof will not be as bright as on the final printed result. Many buyers, in fact, list this as an added advantage of overlay proofing, since the dulling factor eliminates the chance for unrealistically high expectations and the printed result always looks better than what was approved at the proofing stage. This is basically the reverse of what is encountered with laminate proofs.

All overlay proofs have another advantage: Because the acetates are not laminated together, the result is essentially a progressive proof for the press operator to refer to. If something is not right on press, therefore, and color needs to be altered, the operator can review the overlays and see where the problem

may be. Printers using a single-color or two-color press prefer to receive overlay proofs for this reason.

Many buyers, in an effort to save money, specify a laminate proof for color approval and then opt for an overlay proof to check the final stripping. They then submit the laminate proof to the printer for a color match but save money at the revised-proof stage with the overlay proofs for checking position and stripping. This approach is valid, but everyone must realize that the two proofs will not be identical.

In the near future, however, we can look toward a new type of proofing technology, which may alter the costs of color proofing. With more and more work done on CEPS systems today, it makes sense to get proofs from digital data, rather than from film. This concept is known as digital proofing.

DIGITAL PROOFING

The earliest form of digital proofing is widely used at today's color separation plant—this is soft proofing or video proofing. In this technique, the four-color image is displayed on a colored video monitor, letting the operator see what adjustments are needed and then showing the changes. At one time, it was envisioned that these screens would be in every buyer's office; today, this is not the prevailing wisdom. There are several reasons why.

First, the screen image does not match the final

printed result. There is a distortion, partially because of the inherent differences between video and printed impressions, partially because the video image is additive and the printed result is subtractive. Even a trained color operator takes about a year to understand these differences to the point of making accurate judgements on the video screen and being able to predict the final results accurately.

For the print buyer, this problem becomes more complicated. Without a hard-copy proof to refer back to, it is very difficult for most buyers to know what they have approved. Also, each video screen is calibrated slightly differently, so that the color image on the buyer's screen may not match the one at the printer or separator.

The next logical proofing breakthrough area, therefore, is hard-copy digital proofing, with a hard-copy digital proof created from digital data, rather than from film. This has been promised for years, but has yet to materialize as a full-fledged commercial reality. There are several reasons for this:

1. A digital proof must be controllable by the operator making it, and must be repeatable time after time, in the same way that identical proofs can be created from the same film.
2. A digital proof must be accurate and truly represent what the final printed result will be. Film proofs made under tight, quality-controlled conditions by a reliable trade shop have this accuracy; the accuracy of proofs made from digital data rather than film has yet to be proven.
3. The digital proof must show halftone dots that will later be created on the films. Early digital proofing methods do not use halftone dots, making it impossible to anticipate and predict what will happen on press, including such phenomena as dot gain.
4. Ideally, the digital proof (like any proof) should be produced on the same substrate as the final printed job. So far, this is not possible.

In addition to these quality concerns, in order to gain acceptance, the digital proof must offer the following:

1. *Cost reductions:* Since current proofing methods are reliable and acceptable, digital proofing systems must offer some cost reductions to offset the capital costs of the additional equipment. There is great impetus toward these savings, since over 60 percent of all separations require corrective work during the manufacturing process and therefore require more than one proof. If digital proofs can cut down on film and its related costs, the systems can be justified. Today, however, available systems cost over a quarter of a million dollars.
2. *Faster turnarounds:* The printing industry is moving toward tighter and tighter deadlines. To meet these demands, the digital systems have the promise of shortening the production time needed to generate a set of film, and will probably gain acceptance on this basis. It is estimated that digital proofing can reduce proofing time by 50 or even 75 percent.
3. *Better quality:* Digital proofs, once perfected, have the promise of greater predictability. Ultimately, the operator may be able to dial or punch in certain characteristics of the press, producing a proof that *directly* simulates what will happen during that particular press run. Ideally, this would give us press proof without the press, but this technique is not yet ready.
4. *Data transmission:* As technology advances, our world is becoming smaller. There will probably be a need for film data to be transferred via satellite to remote locations around the world. The advent of this technology will bring with it a need for digital proofing data to be transferred along with the digital film data.

There are various manufacturers of digital proofing systems. At the 1990 Drupa trade show, 3M introduced Digital Matchprint, which uses a patented liquid photographic process in which a combination of laser-directed charges and the offset process transfers the image to the proofing stock. This system interfaces with Hell, Scitex, Crosfield, and Screen equipment. Kodak's Approval system is also a digital mechanism. This system uses dry-laser technology and a laminator. Stork's Digital Colorproofer is based upon the electro-photographic proofing process and Scitex laser technology. It coordinates only with

Scitex systems and requires a Scitex Raystar to pick up information from a magnetic tape, pass it through a computer, and then convert it as an image onto a photo semiconductor plate. This plate is then moved robotically to an electro-photographic proofing machine, which produces the actual proof.

All digital proofing systems are in the very formative stage. Their high cost reflects the amount of research it has taken to develop this technology. Despite these problems, however, the industry pressures for speed and economy should force these technologies to develop and emerge as the major means of proofing in the twenty-first century.

NONCONTRACT DIGITAL PROOFS

In addition to these high-quality digital proofs, there are new digital proofing systems that offer lower resolution and lower quality. These proofing systems have been created to work with the new color monitors on personal computer equipment. They are accurate for position purposes only and cannot be used to make accurate color judgments.

One such technique is the liquid toning technology system used by the Iris proofing system, an ink-jet system that uses vegetable-dye-based inks of the four process colors. The ink jets create a proof of only 300 dots per inch—low resolution—which means it is inaccurate for contract color proofing. Du Pont has introduced the 4Cast digital proofing system, which produces a continuous-tone proof rather than a halftone proof. The process involves thermal-transfer technology, which employs a colorant dye ribbon with 100 sets of alternating process-color values. When heat is applied to the back side of the ribbon, the colored dyes transfer to the white receiver stock. Becuase the 4Cast system is not a representation of halftone dots, it probably will not be widely used for contract proofing. It is, however, gaining wide acceptance in the design community for use in producing good comp proofs.

Other proofs in this area include QMS Color script, the Crosfield Jetproof, and the Stork Digital Proofer. There is growing interest in this type of proof because of the growing use of desktop publishing, but no one has yet created a proof that gives you the accuracy and repeatability of film proofs. The future, however, will certainly be one where film and digital proofs exist side by side in the marketplace.

SHOW-COLOR vs. COMPOSITE PROOFS

Because prepress proofs are the major way to determine what your job will look like in print, it is important that you *always* take time to examine them carefully. Too often, buyers get very busy, do not allow enough time for proofing, and then miss some important element. At the same time, don't spend *too* long making decisions—if you take more time than the schedule allows, it will seriously jeopardize your final delivery date. Remember too that your film supplier will have allotted a portion of time to correct a reasonable number of color and other errors. If you want massive changes made, however, arrange time for the supplier to do this work. Many buyers fail to acknowledge the need for this additional time, feeling that "the supplier should have done it right the first time," but this attitude will not magically rewrite a schedule or stop the clock from ticking.

On most four-color jobs you will receive two

proofs. First there will be the *raw color, show-color, random color* or *first proofs*. These will often contain picture elements only, although jobs done on newer CEPS systems may provide first proofs with all elements in position. In either case, the first proofing is when you should pay most attention to color. Since color is very subjective and open to interpretation, there is a good chance you will not agree entirely with the way your color separator has interpreted every transparency—there may be a certain key element missing or not handled exactly right. This

is your chance to tell them what you want done.

Remember to be as specific as possible. Instructions like "a little less blue" or a "prettier red" are of little value to the color separator. Be as objective as possible, showing *exactly* what you want to achieve. If possible, give a color swatch of what you are trying to reproduce (of course, doing this *before* the proof stage, when submitting your original input materials, is the best way to avoid disappointment when viewing the proofs). Show a sample rather than trying to describe something. Your ink-matching book gives

Show-color proofs present only picture elements, not type. All color corrections should be made at this proofing stage. You can make selective adjustments to any of the process-color films (*right*) to get the desired effect on the final image (*facing page*). (Courtesy of Eastman Kodak Company)

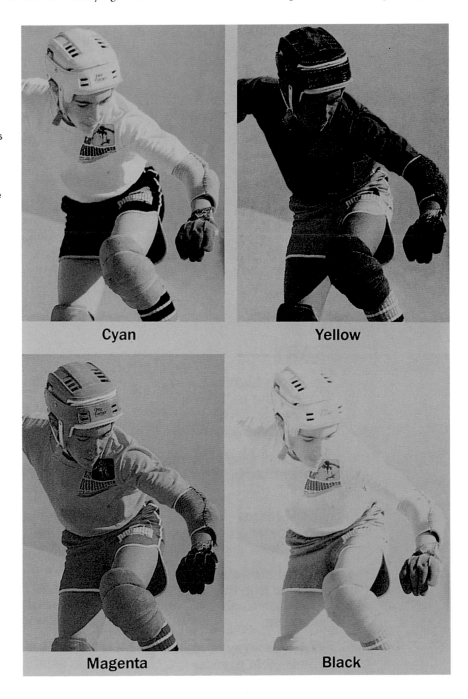

Cyan

Yellow

Magenta

Black

When examining color proofs, first check sharpness. Then look at neutrals (the silver, in this case) and intense colors (the red). (Courtesy of Spectrum, Inc., Golden, CO)

you a wide variety of colors—if you see the color you want to achieve, tell the supplier to match it.

The second proofing step may be called either a *final proof, composite proof,* or *stripping proof.* These terms all refer to the proof made after all color corrections are completed and the page assembly has been done. Occasionally, this step is delayed because a revised set of random proofs is required due to extensive color corrections in the first set. If major color changes are needed, and if you can find time in the schedule, request this extra proofing. Many suppliers charge an additional fee for this, so weigh the cost against your color needs.

In most cases, however, your color should now be correct and you should be using this composite proof to see that all tints are correct, all elements are correctly positioned and aligned, and that the job "looks right." Very often there are few changes or corrections at this proofing stage.

You should always examine prepress or final proofs systematically. Here's how to do it:

First, check sharpness. The most important ingredient in a separation is sharpness. Check small detail areas, such as type on a package, tree limbs in an outdoor shot, pupils of eyes for portraiture, and fine detail in interior furniture shots. When examining these elements, see immediately if the job is in register and sharp. Misregistered film blurs the subject and can cause a color shift.

Next, check neutral areas. Always be sure to judge neutral areas before judging overall color. If the neutrals are incorrect, the entire separation is out of balance. First check the highlights—see that the whites are a pure white, the grays a neutral gray. If either of these has a noticeable color cast, such as green or pink, the whole subject may reflect that same color.

Next, check the shadows. The blacks should be a true black without a greenish or bluish color cast. Again, a distortion means that the entire separation is out of balance.

Check overall color. Does the overall rendition look appealing? Start by checking the intense colors.

If the reds appear less brilliant than desired, perhaps there is too little magenta, yellow, or cyan. If this is the case, go back to the neutrals and look again for a color cast: if there is a bluish cast in the grays and you are displeased with the reds, perhaps there is too much cyan in the film; if the grays have a greenish cast, however, the magenta may be too weak; and if the grays have a blue-violet cast, the yellow may be too weak.

Look at the greens. If they appear diminished and somewhat brown, any of the three subtractives may be at fault. Again, turn to the neutrals: If the gray has a reddish cast, the magenta may be too heavy or the yellow and cyan are too weak. To determine which is at fault, look at a strong yellow or blue and see which of them is weak.

Remember, most of the colors we reproduce are strong combinations of two process colors with a tertiary amount of a third. In browns and flesh tones, however, there are three critical colors, which is why these colors are so difficult to reproduce—any small variation in *any* of the three colors can cause deviation in the reproduction. Flesh tones are particularly difficult to reproduce when they are illuminated by mixed light sources, such as strong illumination from a window on one side of a face and a fluorescent light on the other.

Once you have checked everything carefully, you must sign off on the proof. Even if the supplier made a mistake, that mistake is *your* mistake once you sign off. After signing off, return the proofs promptly—the standard turnaround time is one or two days. If you need to keep the proofs longer, make sure you discuss this with your supplier when they first establish the schedule for your job.

If minor type corrections are made at this final proofing step, your supplier may suggest an inexpensive blueline or brownline proof to show these simple corrections. This is less expensive than another full-color proof, but should be used only for pages with simple type corrections or position changes. Anything involving color should be represented by a new color proof.

COMMUNICATING COLOR

Despite all the technological advances in proofing, there is still the challenge of communicating your color needs. Many buyers use the Kodak Print Filter Kit to help accomplish this. This kit consists of a series of colored acetates. Because the acetates are the same in each kit, they act as a standard, so that if you and your supplier both have kits, you can communicate with each other by referring to the "plus 10Y" filter over the red area in your picture.

These acetates, however, were developed for color print making in the photo lab, not for four-color printing, so be sure not to use them to indicate literally what you want done to the separation (e.g., "Add 10Y to the red area"). use the filters only as a standardized reference so you and the separator can look objectively and discuss changes in the same context.

Finally, keep in mind that despite the strictest quality-control measures, proofs *will* vary. In fact, if

The Kodak Print Filter Kit consists of a series of colored acetates. These guides can be used when evaluating proofs to help predict the effect of color alterations. (Courtesy of Eastman Kodak Company)

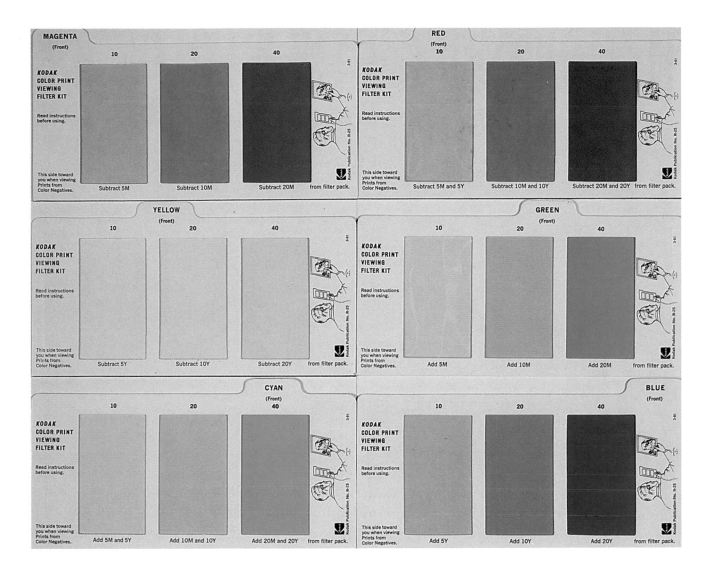

The filter kit includes acetates for both additive and subtractive colors. (Courtesy of Eastman Kodak Company)

the same films were sent to every proofing manufacturer with instructions to create a "perfect" prepress proof under carefully controlled laboratory conditions, no two proofs would be identical. Actually, on any given day, depending on any number of variables inherent in a four-color printing job, you can always expect to see differences in color. Proofs, therefore, must be considered *guides* to what your job will look like, rather than as absolutes.

For this reason, many buyers of four-color printing prefer to be at the press for a final okay. This approach is valid. There are an incredible number of variables to contend with at the press, and remember, the proofs were created without any regard for type, line art, and the other noncolor elements that will appear with them. These factors make it a good idea to be at the press to make the adjustments and decisions that only you should make about your project (further information on press checks is discussed in Chapter 11).

11 PRINTING A FOUR-COLOR JOB

PAPER

Paper, the light source for all printing, can affect the quality of your printed piece more than any other factor, especially on a four-color job.

Yet paper also typically represents at least half of an overall printing charge, so when buyers want to save money, they often try to do it on paper. As the price of paper and printing has gone up, and as mailing costs have escalated as well, large- and small-volume print buyers are lowering the quality of the paper they use, resulting in poorer print quality.

There are four considerations to make in selecting the right paper for a four-color job. First, consider the *weight* of the paper. The weight of a given paper is measured with a caliper and refers to the weight of 500 sheets of the stock in a 25-by-38-inch size. The greater the weight of the paper, the higher the quality of the printing job, but the more expensive it will be

The printing paper acts as a substrate for the inks, which determine which light wavelengths will reflect back to our eyes. (Courtesy of Eastman Kodak Company)

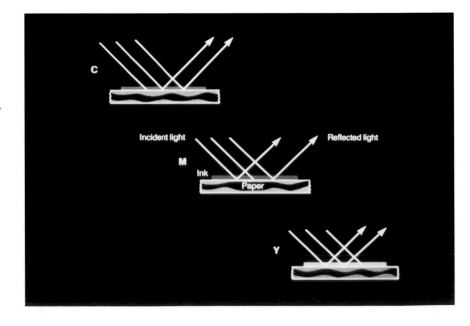

as well. Most four-color jobs use somewhere between a 50- and 100-pound stock. Within this wide range, mass-circulation publications often fall into the lower weight, and slick annual reports and high-quality sheetfed pieces use the heavier papers.

Opacity refers to a paper's ability to hold ink and prevent "show through." Two different papers of the same weight may have entirely different printing results because one is more opaque than the other. The more opacity in the paper, the better a four-color job will look.

Also consider the *surface* of the paper. Four-color jobs are usually printed on either dull-coated, matte-coated, or gloss-coated stock. Coated papers have been covered with a material that is at least 50 percent pigment. The pigments, such as clay, calcium carbonate, or plastic, can be applied to one or both sides of the sheet. Coated papers are better for printing than uncoated stock, because the coating will hold a higher percentage of the printing ink at or near the surface of the paper. This phenomenon, known as *ink holdout*, is extremely important in producing a good four-color piece. Coated papers are also smooth, which allows the printing dot to reproduce as closely as possible to its original size and shape on the film.

The choice between the three coated surfaces can be affected by budget and personal preference. Many buyers like the gloss-coated because of its high brilliance and color fidelity. This surface is capable of achieving maximum ink density, and its smooth surface minimizes the effects of dot gain, but glossy surface causes glare. For this reason, many people feel that jobs printed on gloss-coated papers are difficult to read.

Dull-coated stocks present a compromise between good color fidelity and lack of glare. Despite the slightly more limited ink density and greater dot gain, dull-coated sheets are easier on the eyes. If your budget permits, you can also *spot varnish* the four-color images on your dull-coated sheet, giving you the benefit of high-gloss color without the glare effect of the gloss-coated sheet.

Matte-coated papers are the least expensive and least desirable stock for good color reproduction—

ink density and tonal range are reduced, and dot gain is increased. The matte coatings have a high fiber content, however, so they are strong and durable, making them ideal choices for textbooks and other printed projects that require long life.

One new trend is the move toward recycled papers for four-color printing, an option requested by many buyers due to environmental concerns. Because these papers are more expensive and can cause printing problems, however, anyone using them should work carefully with the printer and separator in order to avoid becoming a guinea pig for testing a new paper.

The last consideration is the *color* of the paper. While almost all four-color jobs are printed on a white stock, there are differences in the brightness characteristics of papers. The American Paper Institute, a trade group based in New York, has established five categories of whiteness standards, and all papers, regardless of brand, have been classified in grades from one through five. These grades refer to the amount of whiteness or brightness in the paper, with grade one having the highest degree of whiteness and grade five the least. The brighter the sheet, the more accurately and purely it will reflect the transparent inks, and therefore the better the color you will see. And, obviously, the higher the grade of paper, the more expensive it will be.

If your paper tends toward the gray or yellow and is not quite white enough, all color will appear dull and lifeless. A similar result occurs when you have a bluish paper. This sheet absorbs more red and green than normal and thus the color appears to have a gray cast. If paper has a bias in any direction, you will not get accurate color.

COLOR PRINTING

The culmination of all we have discussed happens on the printing press, where all your planning and work results in a fine printed piece. The chances for error, however, are not over; in fact, they are just beginning. All the chances for mistakes that have occurred until now can be doubled when you get to the press. There are infinite variables that must be controlled to get the printed job you originally envisioned (Fig. 11–1).

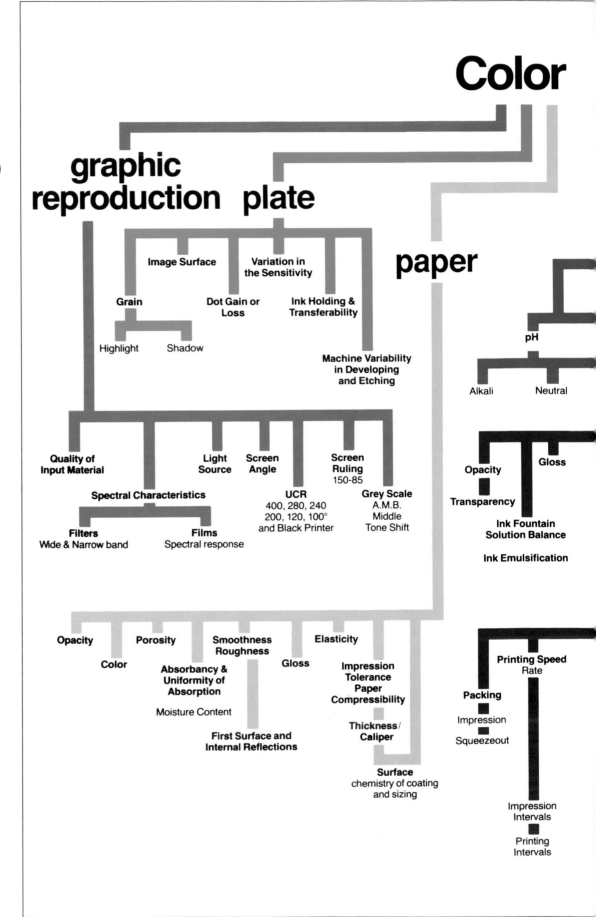

11-1. There are many variables in a four-color print job. By understanding these factors, you can routinely produce good-looking four-color projects. (Copyright Sun Chemical Corporation, 1987, used with permission)

Printing Variables

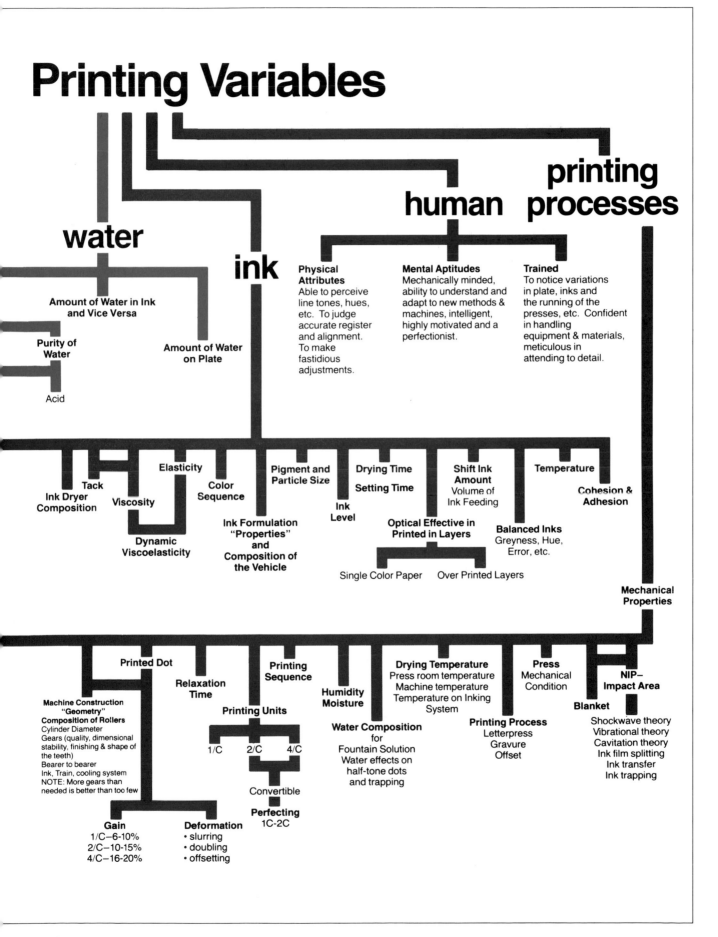

water

Amount of Water in Ink and Vice Versa

Purity of Water

Acid

ink

Amount of Water on Plate

human

Physical Attributes
Able to perceive line tones, hues, etc. To judge accurate register and alignment. To make fastidious adjustments.

Mental Aptitudes
Mechanically minded, ability to understand and adapt to new methods & machines, intelligent, highly motivated and a perfectionist.

Trained
To notice variations in plate, inks and the running of the presses, etc. Confident in handling equipment & materials, meticulous in attending to detail.

printing processes

Elasticity

Tack

Ink Dryer Composition

Viscosity

Dynamic Viscoelasticity

Color Sequence

Pigment and Particle Size

Ink Formulation "Properties" and Composition of the Vehicle

Drying Time

Setting Time

Ink Level

Shift Ink Amount
Volume of Ink Feeding

Optical Effective in Printed in Layers

Single Color Paper Over Printed Layers

Temperature

Balanced Inks
Greyness, Hue, Error, etc.

Cohesion & Adhesion

Mechanical Properties

Printed Dot

Relaxation Time

Machine Construction "Geometry"
Composition of Rollers
Cylinder Diameter
Gears (quality, dimensional stability, finishing & shape of the teeth)
Bearer to bearer
Ink, Train, cooling system
NOTE: More gears than needed is better than too few

Gain
1/C—6-10%
2/C—10-15%
4/C—16-20%

Deformation
• slurring
• doubling
• offsetting

Printing Sequence

Printing Units

1/C 2/C 4/C

Convertible

Perfecting
1C-2C

Humidity Moisture

Water Composition
for
Fountain Solution
Water effects on
half-tone dots
and trapping

Drying Temperature
Press room temperature
Machine temperature
Temperature on Inking System

Printing Process
Letterpress
Gravure
Offset

Press
Mechanical Condition

NIP– Impact Area

Blanket
Shockwave theory
Vibrational theory
Cavitation theory
Ink film splitting
Ink transfer
Ink trapping

To plan a trouble-free print job, get a copy of the printer's imposition and plan your job to avoid compromises on press. (Courtesy of Spectrum, Inc., Golden CO)

This side prints in one color.

This side prints in two colors.

Many fine printing jobs have been ruined because of unclear instructions to the bindery. To avoid this problem, always submit a folding dummy. (Courtesy of Spectrum, Inc., Golden, CO)

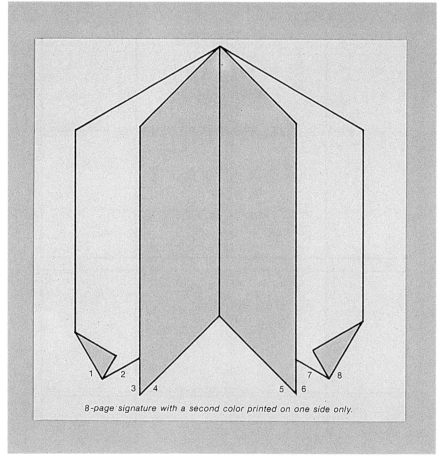

8-page signature with a second color printed on one side only.

To minimize your chances for problems on press, it is important to consult with the printer early and make sure you are not designing problems into the job. Show the printer any rough sketches and dummies and get feedback about any potential problems—perhaps then can be easily redesigned out of the project.

Always be sure to see a copy of the printer's *imposition*. This is the map that shows how the job will run on the press. Be especially aware of which pages run in line with each other (that is, which pages follow each other through the press). Whatever ink density is needed by the first page in line will influence the ink on the pages following it. Thus, if a page with a heavy blue area is followed by a page with virtually no ink needed, there may be a ghosting effect, or streaks, on the third page down the line. Avoid this problem by rearranging the page sequence.

Also, remember to provide a folding dummy to the printer when sending final art boards or film. This is a mock-up of exactly how the job will trim and fold when bound at the bindery. Although you can "buy" extra time throughout almost every other production phase, there is never any time to spare at the bindery, so last-minute changes or delays are impossible. Projects with perfect color and beautiful printing can be ruined by unclear or erroneous binding preparation, so be sure your folding dummy is accurate and straightforward.

Other tips for trouble-free printing include the following:

1. Always design your printed piece to take advantage of standard press and paper sizes—a project requiring special-sized paper will cost more and is more likely to encounter problems on press. Check with your printer and allow enough space for the "gripper" as well as space for color bars.
2. Send all materials to the printer at the same time. Piecemeal shipments cause problems and make inefficient use of the printer's time.
3. Select and position pictures with care. Ideally, do not have photos running through the page gutter of a piece except in the center spread—it is

difficult to align the two different parts of an image and maintain consistent color when each side has been printed in a different page, and even more so when the two sides fall in different signatures (page groupings printed in separate press runs).

4. Always be careful with reverse type. To reverse successfully, type should be sans serif and large—ideally, at least 10 points, although this varies with the type of press and paper being used.
5. Avoid designs that *must* have a perfect trim. No press is perfect, and trim sizes cannot be held exactly. Maintain a safety area and do not put design elements outside of it—a good measurement to maintain for such an area is three-quarters of an inch.
6. Listen to your printer regarding the appropriate screen ruling for your job. Remember, at somewhere between a 133- and a 150-line screen, the eye cannot perceive a dot pattern.
7. Take care when overprinting type on a four-color or tint image. Avoid busy areas in photos.
8. Reproduce all thin lines, boxes, and rules in one solid color only. Trying to keep these lines registered in two, three, or four colors can cause problems.

DENSITOMETERS, COLOR BARS, AND QUALITY CONTROL

The printer has a wide range of tools available to diagnose printing problems. The principal diagnostic tools are the *color bar* and the *densitometer*. Always insist that these tools be used when printing a four-color job.

The color bar is a piece of film burned into the printing plate that becomes a mirror to what is happening on the printing job. The printer's color bar works much the same way as the photographer's photographic gray scale (see Chapter 6): It acts as a constant, a dependable reference point of known values. If there are any problems on the press, the printer can see how the color bar is reproducing, measure the bar with a densitometer, and use this information to help evaluate the overall situation.

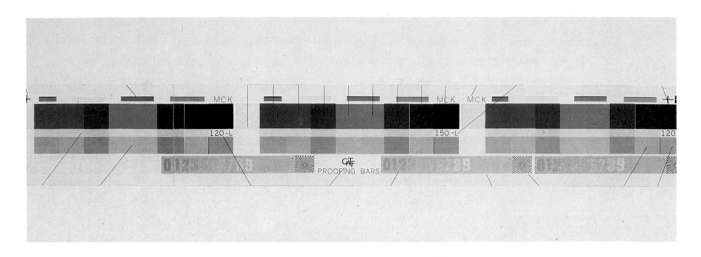

Above. A color bar, including solid blocks and trapping blocks, should be printed on every four-color sheet. (Courtesy of Spectrum, Inc., Golden, CO)

It is essential for your film to match the printer's requirements. A densitometer can measure film density and avoid ink-trapping problems.

Color bars are made by various manufacturers, but they always should contain the following:

- First there are always the solid square bars. These squares show the ink density of each of the four process colors when printed at 100 percent. The densities of these solids should correspond to the densities noted on the printer's spec sheet.
- There should also be trapping blocks on the color bar. These squares indicate the color result when two solids trap or print on top of each other. These trapping blocks should show one of the primary colors.
- The color bar also has three color patches and patches of various screens of the process colors.
- The gray balance patches of the color bar show

three colors overprinting at different screen values, indicating the overall color balance. A change in these patches during a press run can indicate a serious color shift.

The GATF color bar, the most widely used and comprehensive bar, has some additional elements, including star targets, slur targets, and doubling targets, which show the condition of the printing dots themselves. There is also a numerical indication of the dot gain printing across the sheet.

The second printer's tool is the densitometer, a device for measuring the ink density on the printing sheet. Today, many of these devices are computerized and quite elaborate. It is very important that the printer use the densitometer regularly—while the

color bar is the testing device, the densitometer is the way to measure the *results* of the test. The two tools work in conjunction with each other, and neither can function properly without the other.

PRINTING STANDARDS

As printers have refined their art, there has been a move toward standardized printing specifications, especially in web printing. The standards movement was initiated by the magazine printers, because they work with film from various advertisers, combine them with editorial film, and then run the entire job. The wide variety of film sources led to a correspondingly wide variety of film formats and quality levels, making the printer's job nearly impossible.

For this reason, the publication printers, advertising agencies, color separators, and publications met and developed *SWOP standards*. SWOP stands for *Specifications for Web Offset Publications*. SWOP standards are constantly revised, but they have succeeded in bringing uniformity, consistency, and higher quality to web offset publications. (For a copy of the current SWOP Specifications, contact the Graphic Communications Association, 1730 North Lynn Street, Arlington, VA 22209.)

Commercial web printers and high-quality sheetfed printers produce their own spec sheets (Fig. 11–2), which detail how they want the film prepared. When selecting a printer, make sure to obtain a copy of this spec sheet, and pass along a copy of it, along with the name of your CSR at the printer, to your color separator. While you're at it, furnish a paper stock sample to the separator, so they can be sure of producing your film with the proper film characteristics (film density, screen ruling, trapping, and so on). All of this will ensure that your film is prepared correctly.

In fact, film specs are often overlooked by everyone *but* the separator. It is most important that all aspects relating to the film, including emulsion requirements, marking requirements, and so on, are strictly adhered to. When you receive your film from the separator and pass it on to the printer, be sure that the printer's film-inspection staff checks the film thoroughly to confirm that all specifications were met.

High-quality printers have a variety of quality-control devices for ensuring a consistent job. (Courtesy of Eastman Kodak Company)

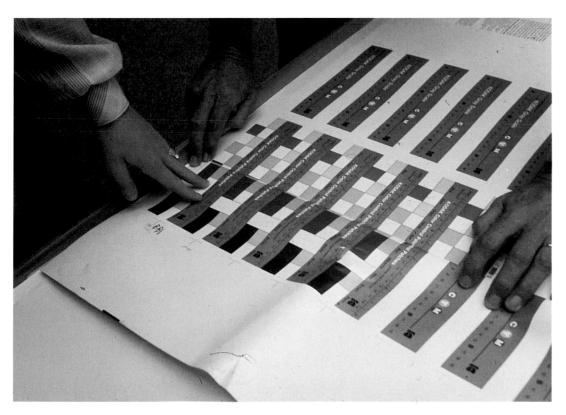

11-2. A typical printer's spec sheet. (Courtesy of World Color Press, Inc.)

WORLD COLOR PRESS FILM AND

FILM PREPARATION

Type Reproduction

1. *Fine Lettering.* Thin lines, fine serifs, and medium or small lettering should be restricted to *one color.* Reproduce all colored lettering with a minimum of colors.

2. *Reverse Lettering.* Reverse lettering should be carried in areas of the illustration that will offer maximum contrast between the reverse and the image. Use the dominant color (usually 70% or more) for shapes of letters and, where practical and not detrimental to appearance, make lettering in subordinate colors slightly larger to reduce register problems. Reverse type smaller than 8 points, and type with fine serifs, cannot be used. Critical register cannot be maintained if smaller than 8-point type is used.

3. *Surprinting.* Use a screen of not more than 30% for the background where type is surprinted.

4. *Position to Trim.* Type and other image areas not intended to bleed must be held ideally $^5/_{16}$", and a minimum of $^1/_4$", from the final trim.

Vignettes

Fade-away or vignette edges are acceptable. It should be recognized, however, that some of the fine dots on the edges of a vignetted area may be lost or intensified. This could cause some relocation of the edge of the vignette, and also cause a shift or color balance on the edge.

Screen Rulings

Halftone screens will reproduce best with the following guidelines:

1. *Newsprint or uncoated stock*: 85-line to 100-line maximum.

2. *Coated stock with b/w halftones*: 110-line preferred, 120-line maximum.

3. *Publication-grade coated stock with 4/c process*: 133-line preferred, 150-line maximum.

4. *Cover stock with 4/c process*: 133-line to 150-line screens are acceptable.

5. *Laser scanner separations on coated stock*: 120-line setting of scanner recommended. This produces approximately 120-line yellow, approximately 126-line magenta, and 165-line cyan and black.

Screen Angles

The screen angles of the major colors should be at least 30 degrees apart, with the yellow at 15 degrees between the cyan and magenta or between the cyan and black. It is desirable to have the dominant color on the 45-degree angle. This will be magenta in most cases.

Undercolor Removal (Total Dot density in Picture Areas)

This specification varies, in percentage terms, the total amounts of cyan, magenta, yellow, and black in the shadow areas on the printed

PROOF SPECIFICATIONS

image. The preferred sum of the total densities of four colors is 280% with 300% maximum acceptable, and no more than 170% in two colors. In order to reproduce black, the undercolors should be in a neutral or gray balance.

B/W Halftones

Shadow areas should not exceed 90% and highlight areas should be no less than 10%, or loss of detail will result.

FINAL FILM

Film Required

Furnished film should be on dimensionally stable identical 0.004"-thick base. Unless otherwise specified, it should be in negative form, reading right and emulsion down. These negatives should be hard-dot, one piece per color, in register, with no etching or hand color corrections. They should be free from fogging, stains, or dust specks. Dot size on the film must match supplied proofs or progs. All film must be identified by color.

Register and Crop Marks

Film for color ads should have four center register marks located approximately half an inch outside the bleed area. Crop marks indicating trim and bleed should be contacted into bleed ads and must be accurate for register and position. Non-bleed ads should be supplied with position marks. Odd-sized or "universal" ad material must be

submitted with a mechanical showing position for all elements.

Fold and Cut-Off Tolerances

Two-page spreads and other cross-over material are subject to variations in both the press and bindery areas. A maximum of $1/32"$ variation can be expected in each area. A total variance of $1/16"$ could occur if both press and bindery vary in the same direction. Keeping critical alignments within the same press form will help to minimize variation in both alignment and color.

PROOF SPECIFICATIONS

1. *Proof Types.* All supplied film must be provided with appropriate color proofs. Matchprint is the preferred process for proofing; Cromalins and progressive proofs are acceptable alternatives. Tearsheets from previous insertion are not acceptable. All proofs must be prepared in accordance with SWOP standards.

2. *Matchprints and Cromalins.* All toners and tone sheets must match shade and strength of SWOP standards plus or minus 0.07 in density. Each proof must have a solid block of each color that can be densitometer checked to verify conformance to standards.

3. *Press Proofs.* Progressive proofs should be pulled in the same direction as the production press, head to foot. If any corrections to color are marked on the progs, we assume no responsibility for their reproduction on paper. We will

reproduce the film to the best of our ability. Standard SWOP Proofing Inks should be used on standard 60# basis weight paper of 70 (nominal) brightness. Several specific papers meeting these specs are listed in SWOP. "GATF" type proofers and color bars are to be included and run in-line. Densities of color should be run to within plus or minus 0.07 of the Standard Offset Color References.

4. *Two-Color Proofs.* These must be proofed with the "clean" color down first. Total density of two-color or duotone work is not to exceed 170%.

5. *B/W Halftone and Line Work.* All such work should be submitted with a velox proof.

6. *3Ms and ColorKeys.* These are proofs consisting of clear film layers carrying each color, overlayed in register. The primary purpose of this type of proof is as an editorial or proofer's tool. This type of proof is highly interpretive in nature, subject to variation in color by viewing angle and light source. The subjective nature of these proofs makes it very difficult to guarantee accurate color reproduction when they are submitted as a press color guide.

All 4/c film and proofs will be inspected by our Quality Control Department for the first issue only, unless a cursory or full inspection is requested for any or all subsequent issues. If conditions exist such that we cannot produce an acceptable job, we will advise our customer.

Most spec sheets will cover the same general areas, since printers tend to have the same general concerns. How they *approach* these concerns may differ, but the basic subjects do not vary too much. *Screen angle requirements* are similar for most printers. Most color prepress house equipment is calibrated for the proper screen angles to avoid moirés. Newer color service bureaus, however, using less expensive equipment, may not be using the correct screen angle programs for your printer. Make sure to discuss this at length with your color supplier to avoid problems.

Specs for *undercolor removal*, the technique of reducing the amount of yellow, magenta, and cyan dots in neutral areas and replacing them with black, enable the printer to use less ink and print more smoothly. It is very important, especially when printing on a web press, that the undercover removal requirements be met.

Finally, the printer will specify which types of prepress proofs are acceptable. There will usually be a first selection and some alternatives. If your film supplier is planning to use a proofing system that is not on the printer's list, make sure to discuss this up front with the printer.

PRESS CHECKS

Many buyers elect to go to the press to see that their job runs correctly. Review your proofs and bluelines before you arrive, and mark what is most important to you on your proofs. This will help you organize your time—the press will be running at very high speeds, forcing you to make decisions quickly, so do your homework beforehand.

COLOR TROUBLESHOOTING GUIDE

IF THE PROOF OR PRINTED SHEET APPEARS. . .	THE TROUBLE MAY BE. . .
TOO YELLOW	The Yellow printer is too heavy (overinked); **or** Magenta & Cyan are too weak (underinked) **or** poor viewing lights
TOO GREEN	Too little Magenta (underinked); **or** too much Yellow & Cyan (overinked) **or** poor viewing lights
TOO RED	Too much Magenta (overinked); **or** too little Cyan (underinked) **or** poor viewing lights
TOO BLUE	Too much Cyan (overinked); **or** too little Yellow & Magenta (underinked) **or** poor viewing lights
TOO LIGHT, EVERYTHING WASHED OUT	Too little Yellow, Magenta, Cyan, Black **or** reproduction curve incorrect
COLORS WASHED OUT, SHADOWS OK	Too little Yellow, Magenta, Cyan; poor ink/water balance on press in 3-colors; **or** lift black proof layer to judge color saturation **or** reproduction curve/color correction values incorrect
COLORS TOO INTENSE, BLACKS OK	Colors overcorrected in separation **or** colors overinked on press
SUBJECT APPEARS DARK & MUDDY	All four colors too heavy (overinked); press gain; **or** reproduction curve incorrect **or** poor viewing lights **or** poor paper choice for subject
DARK AREAS & BLACKS BLOTCHY	Poor ink trapping, especially on web press; platemaking flaws (exposure or developing); **or** poor paper choice **or** poor original (Polaroid print, C-Print, airbrushing)
SHADOWS HAVE COLOR CAST	Inaccurate undercolor removal on separations **or** poor ink trapping on press **or** poor viewing lights
MOIRE PATTERN ON PRESS	Slurring (doubling) on press (worn bearings, poor packing, blanket incorrect hardness or worn)
REPRODUCTION GRAINY	Original grainy (wrong film, too great an enlargement) CHECK ORIGINAL WITH MAGNIFIER
REPRODUCTION "SOFT"	Poor sharpness enhancement; poor reproduction curve; **or** original soft (poor focus, camera movement) USE MAGNIFIER **or** reproduction from poor machine-made duplicate transparency
HARD EDGE AROUND OBJECTS	Poor sharpness enhancement (overpeaking)
COMPLETE COLOR SHIFT FROM SEPARATOR'S PROOF TO PRESS	Inaccurate proof from separator; poorly made duplicate negatives; poor viewing lights; **or** one of the following: combination of press gain and poor stock on web press; incorrectly made printing plates; poor trapping on web press; incorrect ink/water balance on press; poor stripping procedures; incorrectly made duplicate negatives for two-up run
POOR FLESH TONES	Poor original materials; **or** incorrect flesh tone settings for separations **or** poor viewing lights
FACES WASHED OUT	Poor original materials **or** poor reproduction curve when making separations

If you detect a problem at a press check, see if you can locate the cause on this chart. Remember, a given problem can have several possible causes, so let the printer have the final word on how to proceed. (Courtesy of Spectrum, Inc., Golden, CO)

In gravure printing, the copper cylinders are always proofed prior to the actual print run, making gravure more precise and consistent than offset, and eliminating the need for in-person press checks. (Courtesy of World Color Press, Inc.)

For safety reasons, many printers do not permit buyers to stand at the press. Instead, they set up the buyers in a properly lit quality control room and bring them press sheets as they come off the press. Ideally, a quality control technician is provided as well, to explain any problems and discuss possible solutions.

Bring any samples of what you want to achieve to the press, including materials you may have already provided to your separator, such as fabric swatches, key product colors, and so on. Remember, however, that these *should* have been correct in your film and prepress proof. Given all the variables in an offset printing, the printer will be hard-pressed to make any significant color corrections on press.

The printer will finally ask you to sign off on all sheets, after which the printer's responsibility is simply to maintain the approved rendition throughout the subsequent course of the press run.

PRINTING TRADE CUSTOMS

Printers, like color separators, have their own set of trade customs. Most are simple, and many are virtually identical to those for separators, but a few are printer-specific and noteworthy.

Specifically, the printer will not be considered responsible for any schedule requirements or prearranged delivery dates if the buyer changes the specifications or does not adhere to the original terms. Also, the printer is responsible only for rendering a "reasonable variation" from the supplied proof, a nebulous term that has yet to be defined. Finally, it is worth keeping in mind that the printer is generally permitted to deliver materials in an amount

10 percent over or under the press run that was ordered. In the case of a 10 percent underrun, the printer cannot bill for more than is delivered, but neither can the printer be forced to rerun the job to make up the 10 percent shortfall; in the case of a 10 percent overrun, the printer can (and will, of course) bill for the extra materials delivered.

All of this should be spelled out in the terms of your contract or purchase agreement with the printer. Be sure to read these terms carefully, and question those that concern or confuse you.

EPILOGUE

When you finally see your job, you will more than likely be pleased. Despite all the variables and complexities of four-color printing, excellent jobs are produced every day. The *perfect* printing job, however, has never been done. Moreover, there is no printer who does not have a botched job hidden in the back of the shop, shown to no one, and yet these same printers produce incredibly beautiful pieces every day.

By following the principles outlined in this book, you can greatly improve your odds of getting a good job without headaches or excessive expense. You will be able to speed up the learning process and produce jobs like a pro after only a short time.

But this book is not enough—no book is. You must constantly learn. The world of graphics and printing is ever-changing, and so you must grow and develop as well. Read trade publications regularly, attend seminars and meet with your peers, as well as with your suppliers. And when you have a question, ask—there really are no stupid questions, only timid people who fail to ask.

After a job is completed, write a note to your sales reps at the printer and separator and ask them how you could do things better. They should be willing to give you hints and suggest ways they might have done things differently. In an atmosphere of trust and mutual cooperation, everyone wins.

The beauty of this industry is that it combines the most modern technology with the subtleties that only the human eye can discern, achieving a delicate balance between art and science. So learn all you can, explore new technologies, and then let your creative vision produce the best four-color printing. Good luck in the 21st century.

CREDITS

Thanks to these graphic arts professionals, who generously contributed their expertise and valuable materials to help make this book a success:

Daniel Dejohn

Dixon Paper Company

Du Pont Printing and Publishing

Dynamic Graphics Educational Foundation

Eastman Kodak Company

GTI-Graphic Technology, Inc.

Gary C. Baker, Photographer

Hoechst Celanese Corporation

Jerry Gabrielse, Photographer, 15541 S. Elk Creek, Pine, CO 80470; (303) 838-6055

Joe Corbell Design and Production

John Madden

Kohler and Sons, Inc.

Kurt Klein

Pantone, Inc.

Quark, Inc.

S. D. Warren Company

Scitex America Company

Spectrum, Inc.

Sun Chemical Corporation

3M Printing and Publishing Systems Division

World Color Press, Inc.

INDEX

Edited by Paul Lukas
Designed by Areta Buk
Graphic production by Hector Campbell
Executive Editor: Mary Suffudy
Text set in 11-pt. ITC Garamond condensed